# With Anxious Care

## THE RESTORATION OF THE UTAH STATE CAPITOL

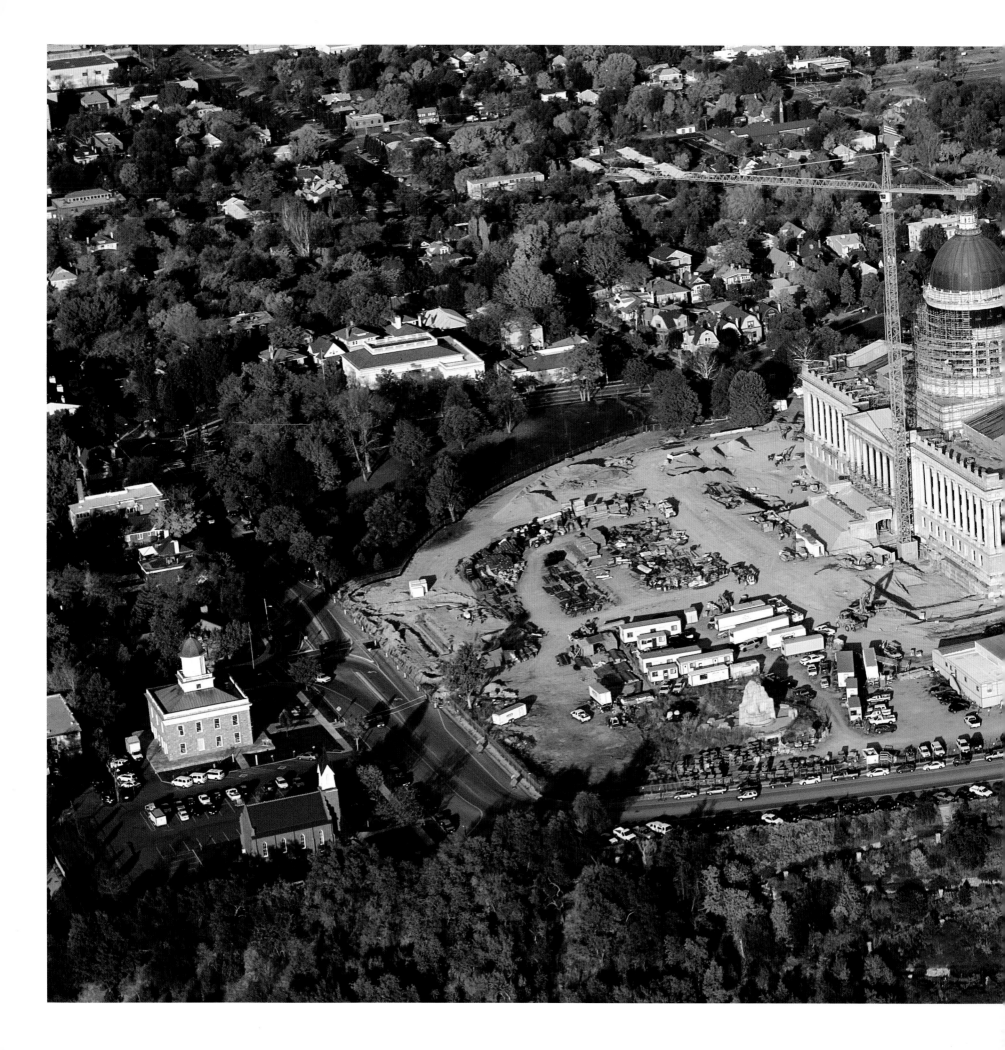

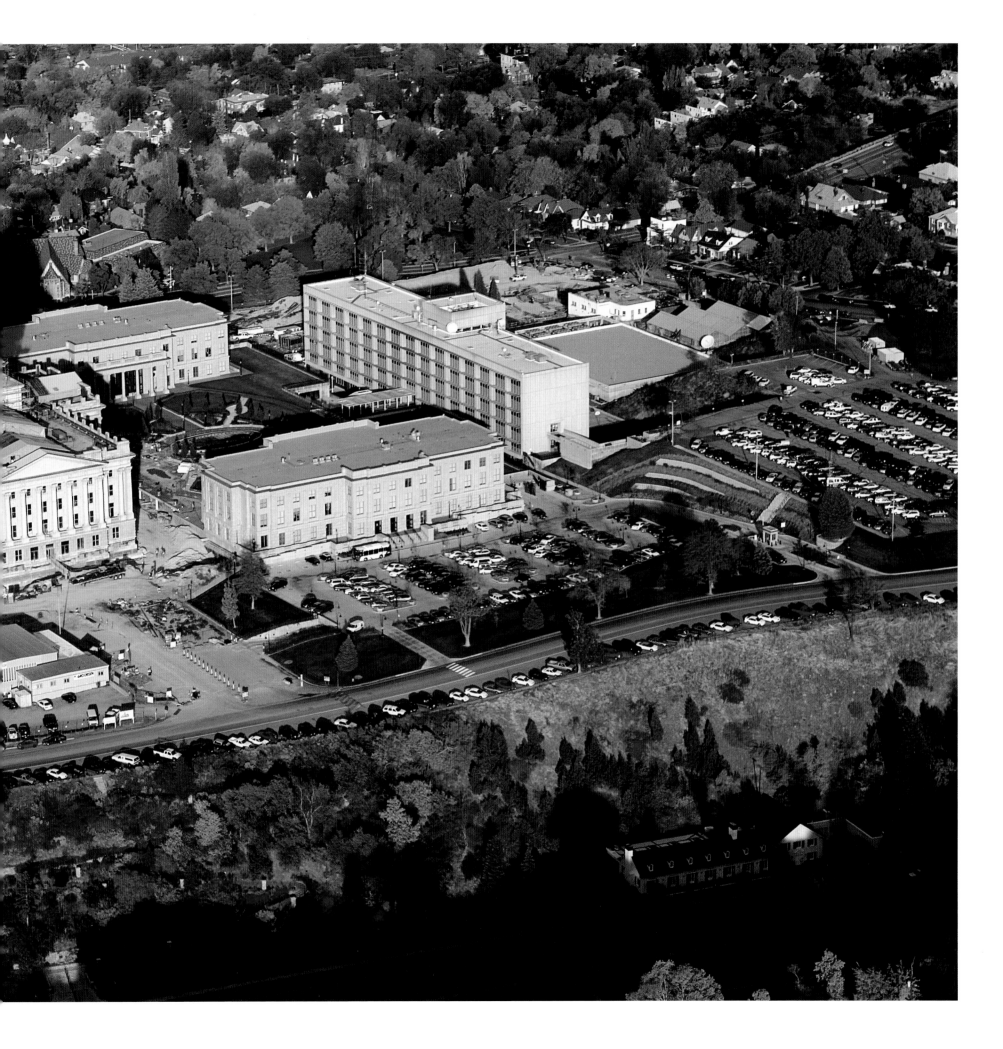

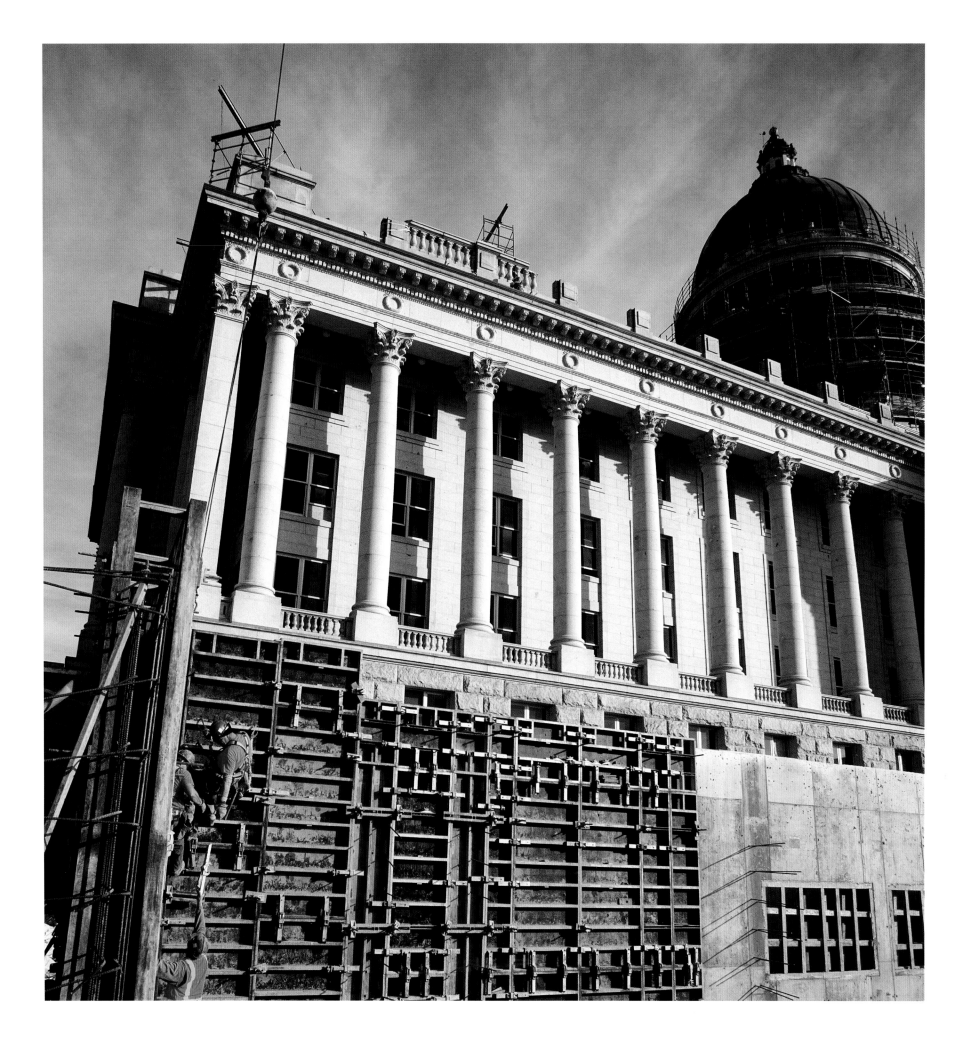

# With Anxious Care

THE RESTORATION OF THE UTAH STATE CAPITOL

STATE
CAPITOL

**Judith E. McConkie**

Curator of the Capitol

**Introduction by**

**David H. Hart, AIA**

Architect of the Capitol

Executive Director of the Utah State Capitol Preservation Board

Photographs by Michael A. Dunn

PUBLISHED BY

The Utah State Capitol Preservation Board

410 North State Street

Salt Lake City, Utah 84114

DESIGN

Dunn Communications, Inc., Salt Lake City, UT

LIBRARY OF CONGRESS CATALOGING-IN-PUBLICATION DATA

ISBN 978-0-615-16880-7

1. Architecture – Utah State Capitol, etc.

2. Social sciences – Utah history, etc.

3. Art and Art history

4. Engineering

5. Historic structures conservation and preservation

Watch an old building with anxious care;

guard it as best you may, and at any cost, from every influence of dilapidation.

Count its stones as you would jewels in a crown; set watches about it as if at the gates of

a besieged city; bind it together with iron where it loosens; stay it with timber where it

declines; . . . and do this tenderly, and reverently, and continually, and many a

generation will still be born and pass away beneath its shadow.

John Ruskin, *The Seven Lamps of Architecture*, 1880.

# Acknowledgments

The renovation of the Utah State Capitol has been a once-in-a-lifetime opportunity for me. For nearly a decade the project has been an all-consuming undertaking that has forever changed me and my family for good.

Without question, the renovation has deepened my appreciation for the political process that takes place within these walls. It has, at times, filled me with awe for the noble ideas that have transpired here. And it has certainly heartened me as I look to the future.

With literally thousands of people to thank it would be impossible for me to recognize all who have joined me in this bold journey. However, I would be remiss if I did not acknowledge a few and thank them for their relentless support, hard work and faith in such a daring undertaking.

First, my deepest thanks to Allyson Gamble, the Director of Public Communications and Visitor Services. She is outstanding and versatile. She along with my loyal staff including Sarah Whitney (who has been with me since the beginning), Joe Ligori (who kept the buildings on Capitol Hill running so that I could focus on the Capitol) and Michelle Poland (a recent and very valuable addition) have listened, worried and worked alongside me every step of the way. Second, I thank the consultants without whom any of this would have been possible. Ray Short was invaluable for his guidance through the legislative process. Paul Brown, AIA, was the clear head in the development of the Master Plan. Paul Ernst, the project manager, worked tirelessly with the contractor to keep everyone on the same page. And Judith McConkie, MFA, PhD, brought knowledge, illumination and, for me, a newfound appreciation for the art, exhibits and education materials. My profound gratitude also extends to the architects, engineers, contractors, subcontractors, suppliers, manufacturers, and fabricators for their hard work, skilled craftsmanship and shared vision of this restoration. Space does not allow me to single them out here, but you will read more about their invaluable contributions in the chapters that follow. Thanks also to the dedicated men and women of the Capitol Preservation Board for their collective faith and unwavering support.

Finally, I recognize and reverence the true visionaries of this project – John Olmsted and Richard Kletting. It has been a joy, honor and delight to pick up their baton and carry on.

**David H. Hart, AIA**

Architect of the Capitol
Executive Director of the Utah State Capitol Preservation Board

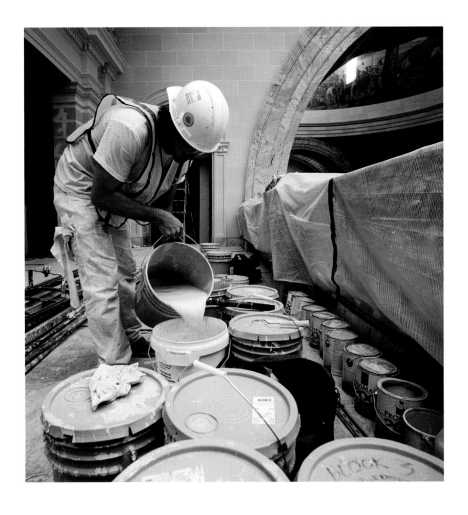
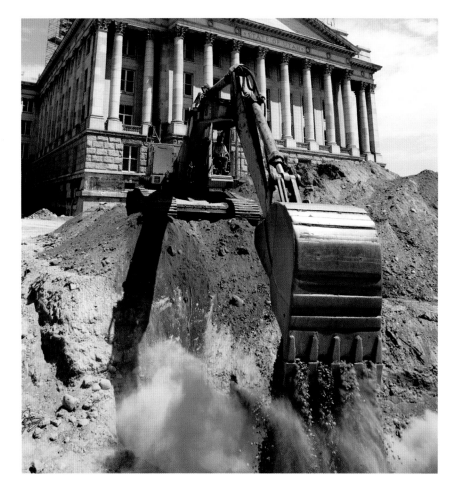
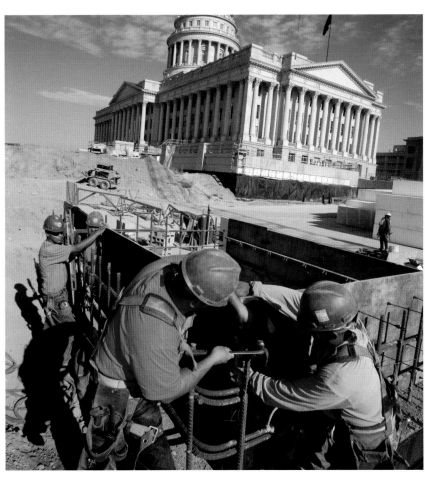
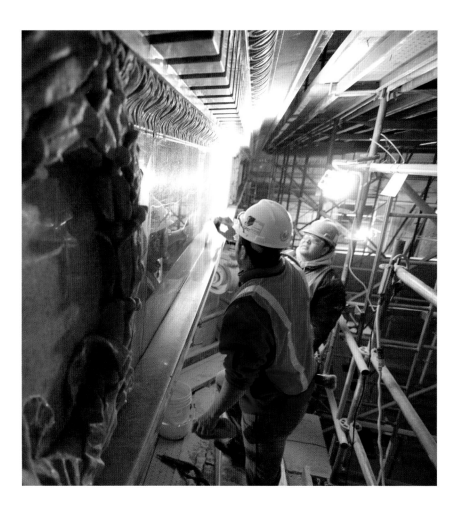

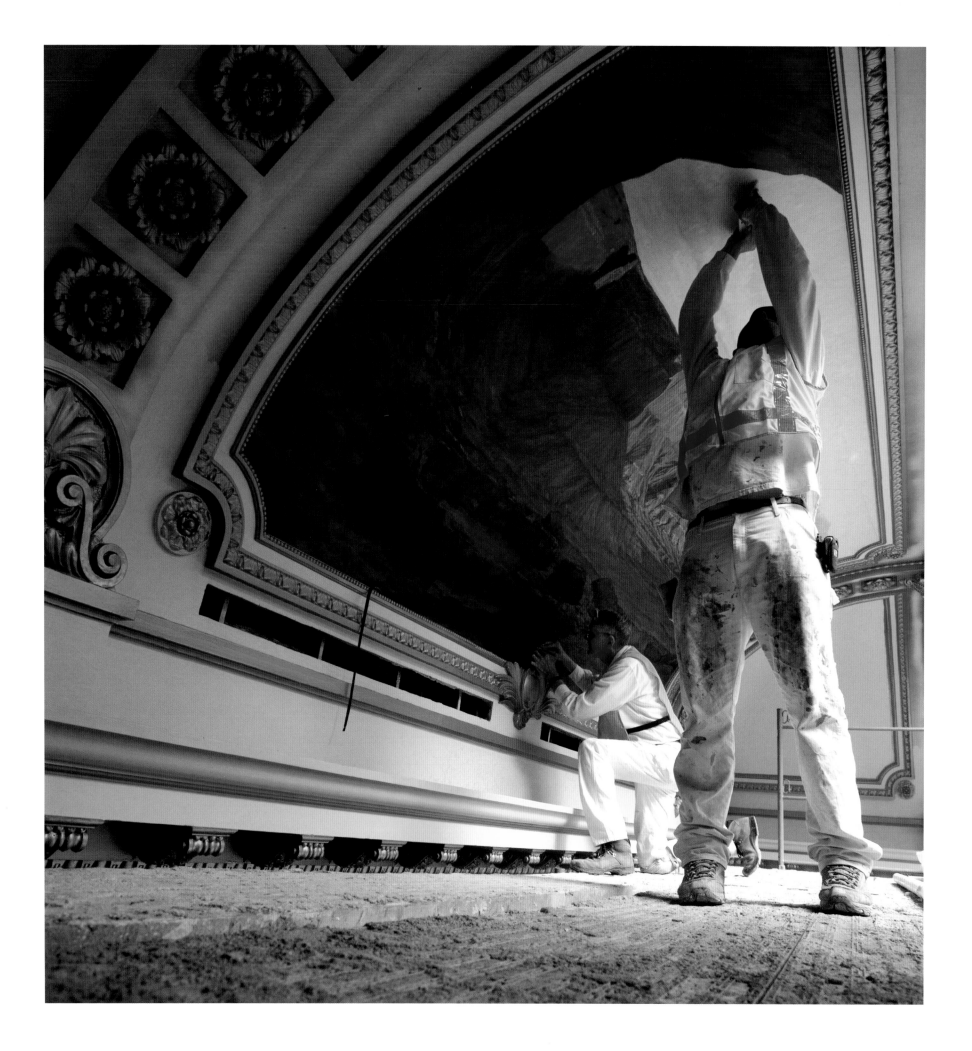

# Table of Contents

**LEFT** Artisans install the new Southern Utah mural by Keith Bond on the ceiling of the Senate Chamber.

# Capitol Chronology

**1850**   Utah is created as a territory of the United States with the town of Fillmore designated as the capital city.

**1855**   The Fillmore Capitol construction comes to an end. (Only one wing of the structure, designed by Truman Angell, is completed.)

**1856**   The Legislature designates Salt Lake City, more centrally located, to be the capital city of the territory.

**1866**   The Legislature begins meeting in the newly completed Salt Lake City Hall.

**1888**   Salt Lake City donates Arsenal Hill, nearly 20 acres of land north of the city, to the territory for a new capitol.

**1896**   Utah is admitted as the 45th state of the United States of America.

**1899**   Under the direction of Representative Alice Merrill Horne, the Utah Art Institute is created and becomes the first state-sponsored arts agency in the country. The state's art collection is begun.

**1907**   Governor William Spry proposes the creation of the Capitol Commission to oversee the design and construction of the Capitol.

**1911**   The Capitol Commission consults with John C. Olmsted, landscape architect, regarding the site for construction of the Capitol.

**1912**   Richard Kletting, Utah's "Dean of Architecture," is selected as the Capitol's chief architect.

**1912**   The Capitol's groundbreaking ceremony is held the day after Christmas. Major excavation of its massive foundation begins.

**1914**   Governor William Spry lays the Capitol's cornerstone.

**1915**   Gavin Jack finishes sculpting the Lions intended for the east and west entrances of the Capitol.

**1915**   Utah State Legislature moves into newly completed Capitol to finish its annual session.

**1916**   The dedication of Kletting's Utah State Capitol is held on October 9, followed by a reception attended by 30,000 visitors.

**1916**   The Utah State Supreme Court meets for the first time in the new Chamber at the Capitol.

**1927**   Gilbert Griswold completes the *Mormon Battalion* monument located on the southeast corner of the Capitol grounds.

**1935**   Works Progress Administration (WPA) artists are commissioned to paint murals for the pendentives and frieze of the rotunda.

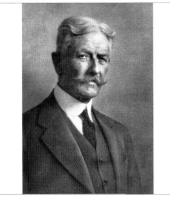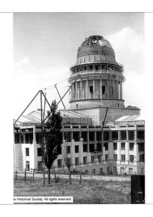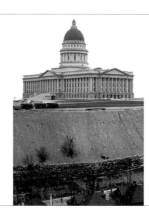

**1957**    In response to tremendous state growth, the Legislature begins plans for the construction of a new office building for Capitol Hill.

**1961**    Dedication of the State Office Building north of the Capitol.

**1969**    Renovations are made to both the Capitol and the surrounding grounds. Much of the interior is repainted, including the inner dome.

**1977**    Ralphael Plescia restores the four Capitol Lions.

**1980**    A new copper roof is installed on the Capitol's dome replacing the one damaged in a severe windstorm.

**1996**    *Brigham Young*, a sculpture by N. Kraig Varner is installed in the Capitol.

**1997**    Sculpture of *Dr. Martha Hughes Cannon* is installed in the niche of the Capitol rotunda.

**1998**    Utah's Supreme Court moves to the Scott M. Matheson Courthouse.

**1998**    The Capitol Preservation Board is created.

**1999**    A rare tornado damages grounds on the south end of the Capitol.

**1999**    David H. Hart, AIA, is hired as Architect of the Capitol and Executive Director of the Capitol Preservation Board.

**2001**    The Master Plan for renovation of Capitol Hill is completed.

**2002**    Construction of the east and west extension buildings is completed.

**2004**    The Capitol is closed for extensive restoration.

**2007**    Seismic base isolation of the Capitol is completed April 7.

**2007**    New murals for the chambers of the House of Representatives by David Koch and Senate by Keith Bond are installed.

**2007**    Four monumental bronze sculptures by Rob Firmin, Jonah Hendrickson and Eugene Daub are installed in the rotunda niches.

**2008**    Utah's restored Capitol is dedicated January 4.

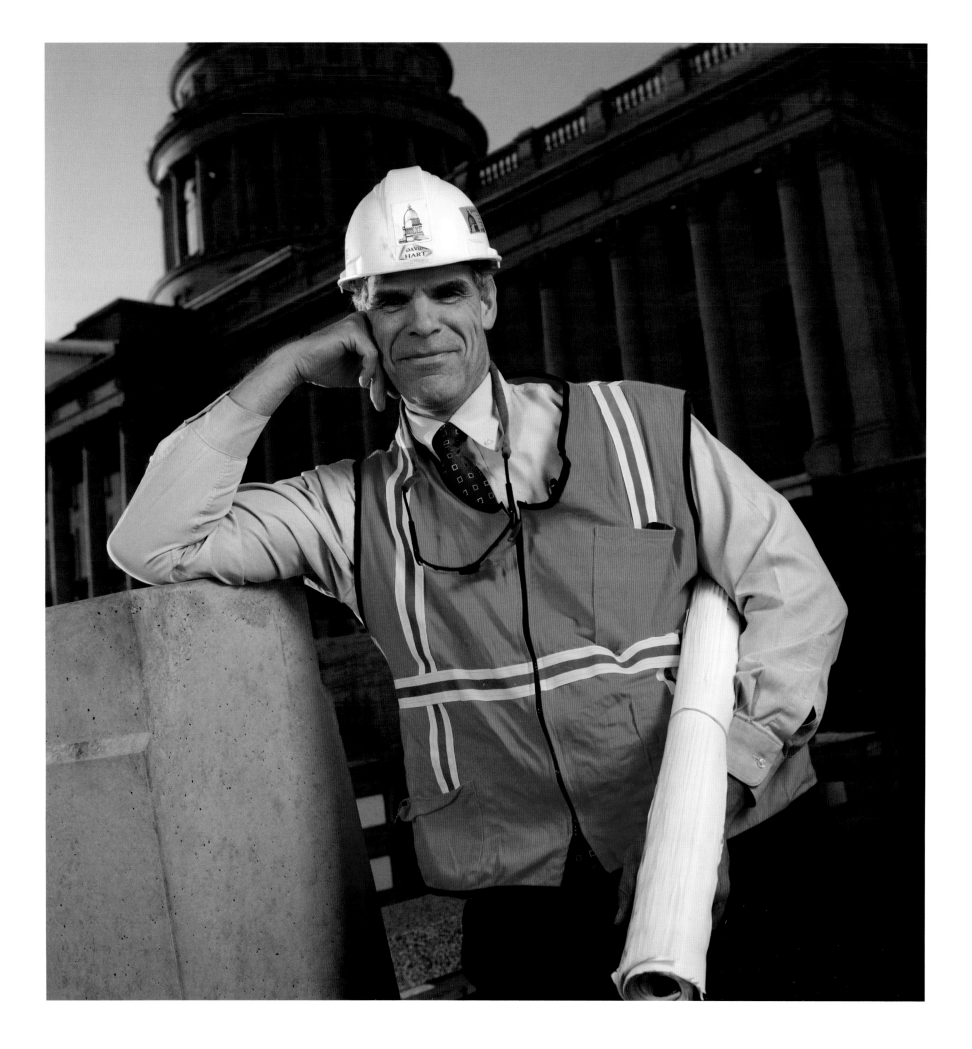

# Introduction

Becoming the Architect of the Capitol was something I would have never dreamed. In fact, in many ways, the job seemed like my worst nightmare.

In 1999, I was approached by a search committee tasked with finding an executive director for the restoration of the Utah State Capitol. The committee asked if I would consider leaving the relative comfort of my private architecture practice in Salt Lake City for the major stress of administering a multi-million dollar project that would stretch out over nearly a decade.

"No," was my unqualified response.

Not only did I not need this kind of headache in my life, but my training was as a modernist and I knew little about the world of historic restoration. Besides, my practice was thriving and I frankly did not want the aggravation or the lengthy commitment to a single project. Nor did I want to be a bureaucrat.

Several weeks later a representative of the Capitol Preservation Board called to ask me to consider the job again. Despite my deep reservations, I consented to an interview. To my complete surprise I was eventually offered the job. And before I could turn committee members down cold again, they added a simple request:

"Just take a walk through the building," they said. "Consider its history and the potential to return it to its former stature."

That idea intrigued me.

That afternoon I made my way to the then dark and somewhat dingy Capitol. As I went up and down the stairs and peeked into timeworn offices and chambers, I sensed a spark inside me. Craning my neck to make out the faded seagulls and murals in the dome, a sense of the building's significance suddenly overwhelmed me. And it was then I realized why.

The Utah State Capitol, with its murals, grounds, and architecture, stands for many important ideals that drive my life. Without the civic freedoms as well as the obligations the Capitol represents, my existence would perhaps be dominated by the selfish interests of the powerful, rather than by the more noble hopes and desires of the people. In that glorious moment I was convinced – not that I wanted to make history, but that I wanted to preserve it.

In order to comprehend the magnitude of the Capitol restoration project, it is essential to understand, in context, the first century in the life of the building and the State. It is also important to know about a Master Plan developed to keep the building and the entire Capitol Hill Complex in exceptional condition for the next 100 years. Knowing the facts in the context of the building's history and its future gives us power to act as responsible citizens.

Contained within the pages of this commemorative book is the story of the Utah State Capitol and its original construction, accompanied by insightful perspectives on its style and design. Through words and images you will discover valuable and interesting information about the myriads of people and processes involved in this grand accomplishment. Literally thousands have contributed their remarkable skills, knowledge and talents to make the building safe and restore its stately beauty.

Finally, just like those who came to me nearly a decade ago, I will now take my turn to issue an invitation. Please join me in reverencing and celebrating this beautiful edifice both in person and in the pages that follow. For it is our house, the "People's House," and forever may it be so.

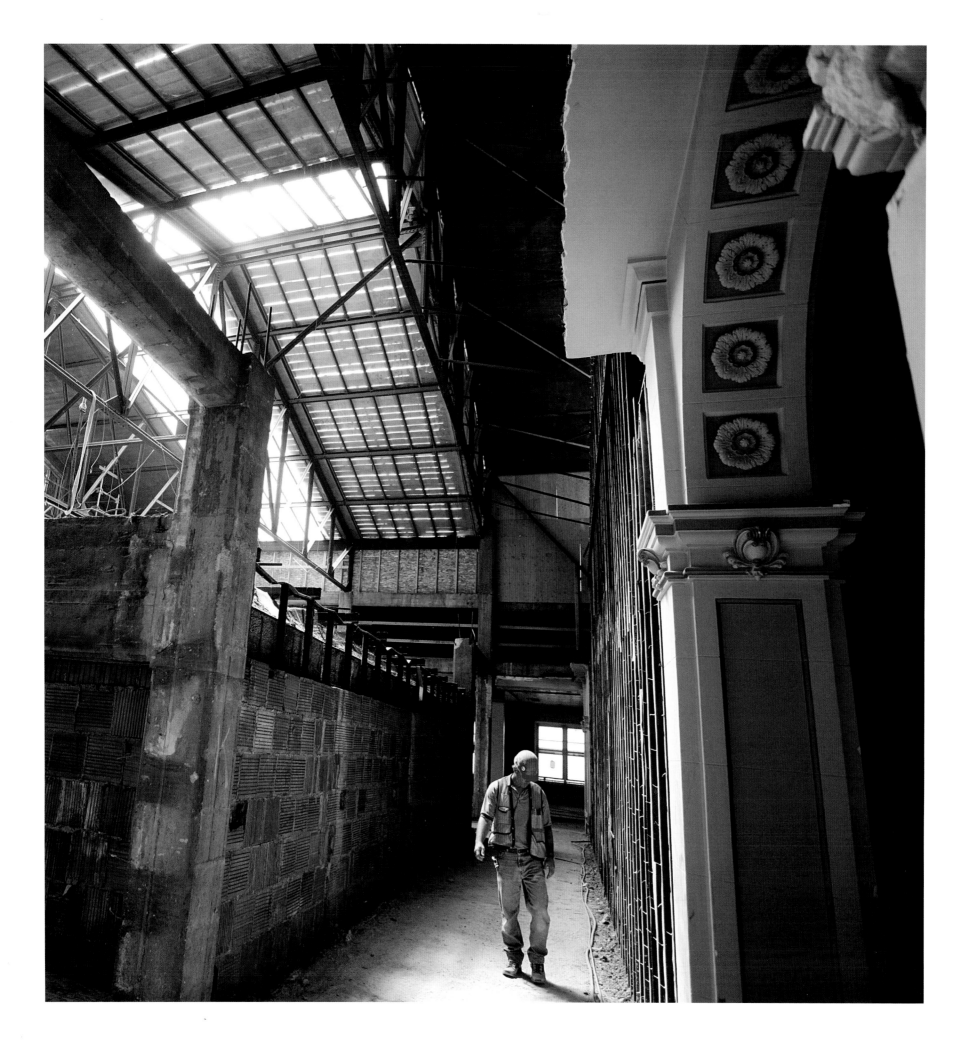

**LEFT** Early in the demolition process, a construction worker surveys original clay walls and steel superstructure on the Fourth Floor above the Supreme Court Chamber.

# The Capitol Preservation Project

The headlines of the three daily Salt Lake newspapers on April 6, 1876 described the catastrophe on Arsenal Hill in large capital letters above the fold on page one. A "DISASTROUS EXPLOSION" rocked the amunition storage site and a considerable part of the community. "Four Persons [were] Immediately Killed and Others Injured. Property damage was extensive."

For the next 36 years, the hill north of the city that had been so cruelly reduced to rubble remained in its fallen state until the duly appointed members of the Capitol Commission turned their shovels full of dirt at groundbreaking ceremonies in 1912. Again in 1916 the same newspapers featured headlines about the hill. This time, however, the papers wrote of the triumph of dedication of a beautiful new state capitol.

In 2008, not only the headlines in the papers but also on the internet and in other broadcast media marked another extraordinary event on the same hill: the re-opening of the marvelously restored Utah State Capitol.

All things considered, it might have been easier to start over, to simply construct a new building using the same plans on the same spot but with revised, updated materials and systems. Contemporary planners might have decided to leave behind a particularly distinctive colonnade but only as a façade or memento of the past to stand in front of a soaring new creation.

In so many ways the restoration of the Utah State Capitol was more difficult. The original construction had been, by comparison, relatively simple, or at least more straightforward. Richard K. A. Kletting's design was elegantly classical and although he added remarkable construction innovations for his day – a reinforced concrete frame for the entire structure, electric lights and elevators, improved fire protection, and even an in-line vacuum system and fire protection – it had been, after all, a post-and-beam rectangle at the base surmounted by a traditional drum and dome above the roof.

However, in 1998 the State Legislature passed and the Governor signed the bill to enable the creation of the Utah State Capitol Preservation Board with complete awareness that the Utah State Capitol restoration project was more than a conscientious renewal of worn or outdated materials. It involved not only the restoration, repair and conservation of the original structure. It entailed the completion of Kletting's

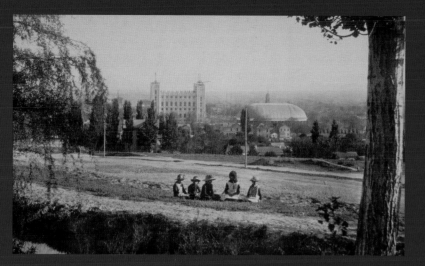
Salt Lake City from Arsenal Hill, c. 1880.

# Arsenal Hill
**by Faye Tholen**

In 1888 Salt Lake City officials gave approximately 20 acres on a barren hill north of the city center to the territorial authority for the future purpose of building a capitol. At first, the gentle rise had been called Prospect Hill because of its position overlooking the entire expanse of the newly settled valley. But by virtue of that advantageous view, in only a few years Prospect Hill had become the headquarters for the Nauvoo Legion, a civil defense group carried over from the Mormon Pioneers' days in Nauvoo, Illinois. The hill had also been the repository for arsenals of munitions belonging to four Salt Lake "powder" companies and their agents. At least 3,000 kegs totaling over 45 tons of gunpowder were stored in warehouses on the site. Early photographs show Arsenal Hill rising a few short blocks north of Brigham Young's compound and Mormon Church headquarters.

Twelve years before the city gave the land to territorial officials, on a bitter cold day in April of 1876, three devastating blasts on the hill rocked the city below and caused widespread destruction. Subsequent newspaper accounts ran for days in the three local papers. The headline in the Deseret Evening News the day after the explosion was typical: "TERRIBLE DISASTER – Terrible Explosion of Forty Tons of Giant, Hercules, and other Powder – Four Persons Immediately Killed and Others Injured – Great Damage to Property." Eyewitness accounts described crowds either running toward the hill to gape at the disaster or away from the site in panic. Emergency workers at the scene found four large holes where the magazines had stood. The ground was strewn with small fragments of the buildings; an iron door was the only whole thing in the wreck. Reports claimed that 30 tons of flying missiles were hurtled about as smoke and debris belched from the hill. Many citizens thought it was an earthquake or volcanic eruption. Some feared it was an invasion from the soldiers at Fort Douglas blowing up the city.

The blast caused widespread destruction and was responsible for the deaths of at least four people. A large boulder went through the mayor's roof and two floors of his new home. Territorial Governor Brigham Young's flour mill, nearly a half-mile away on City Creek, was destroyed. One of Young's daughters was sitting near a window and received a head wound from the shattering glass.

The day following the blast city officials held an inquest at City Hall. Their preliminary verdict was that the explosion was caused by a burning paper wad shot from a gun igniting loose powder strewn around on the site. While there were no formal charges in the matter, the act appeared to be traceable to two teenage boys, Charles Richardson and Frank Hill, who had been grazing their small herd of cattle on the side of Ensign Peak and had been seen taking target practice near the magazines. Both boys were killed in the blast.

The loss of the powder and buildings was estimated at $26,000, while the damage done to the buildings in the city could not be calculated. Officials felt that the severity of the damage was due to the site's commanding elevation above the city. It was decided to locate explosives in a safer area. City officials called a special meeting on April 7, 1876, to expedite the search. The arsenals were moved and Salt Lake City gained a more enforceable explosives ordinance.

It was not until February 28, 1888 that Mormon Church President Heber J. Grant proposed that Salt Lake City should donate the 20-acre plot of the former Arsenal Hill property for a future Capitol site.

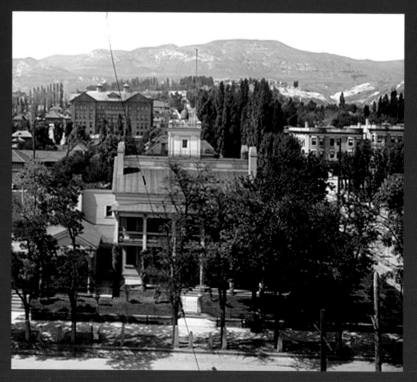
View of Arsenal Hill from South Temple Street at Beehive House.

vision and the seamless integration of new systems and technologies. It required the transformation of a building in danger of collapse during a seismic disaster into a stable and stately residence for the government of the Sovereign State of Utah. And finally, it demanded the preservation of largely intangible, ineffable ideas and ideals concerning the state's past and the promise of its future.

For almost a decade, men and women worked to ultimately preserve and renew Kletting's building, conscious of the complexity of this historic project and driven with a palpable sense of respect for the accomplishments of the original designers, craftsmen and builders.

## The Master Plan

Although talk of renovation of the Capitol had been tossed about for years, the Capitol preservation project began in earnest in 1998 when the State Legislature created the Capitol Preservation Board and gave it responsibility for and jurisdiction over the Capitol Hill Complex. The first order of business for the Board was to hire David Harris Hart, AIA, a Salt Lake City architect with more than two decades of experience in urban design and project planning. He was charged with oversight of the entire enterprise beginning with organizing a series of planning workshops designed to develop a report on the condition of the building and the site and to produce a master plan with guidelines and imperatives for the future of the complex.

Although there was consensus on the fact that the Capitol was in critical need of restoration and stabilization, the Board needed to understand the scope of what should be done. Thus, a team of 19 firms and individual consultants, with the Salt Lake City architectural firm of Cooper/Roberts acting as facilitator convened to write the team's conclusions and recommendations after conducting an extensive study of the existing buildings on the hill. Among other things, the Historic Structures Report provided a well-researched history of the building, a detailed inventory of the entire site, and lastly, a comprehensive series of recommendations grouped around what the report called three "general areas of importance."

The first area of concerns was fairly easy to determine. There was the need to "enhance life safety" for the building's occupants. The second set of concerns was expressed in the imperative to "improve the functional usefulness" of the entire complex. And the third area was the commitment to "preserve the historical and architectural integrity" of the original 1916 structure.

The Cooper/Roberts study was accepted by the Capitol Preservation Board and a set of inevitable but groundbreaking activities were set in motion.

## The Complexity of the Project

The next step was to have David Hart organize a critical series of workshops to develop a Master Plan. Hart in turn asked Paul Brown, AIA, a member of 3DI International, a planning and architectural firm, to be part of the team.

Hart and Brown began meetings straightaway. Not only were qualified professionals in every imaginable field asked to weigh in but also other important stakeholders, interested citizens, and neighborhood residents. The result was very much like a constitution, a governing, dynamic document that will continue to direct planning and development of the Capitol Hill complex in the coming years.

One of the more inspiring conclusions for the entire group developing the Master Plan came at a moment when Hart and Brown realized the entire Capitol preservation project rested on a combination of plans drawn for the first Capitol. John Olmsted, son of the famous landscape architect Frederick Law Olmsted and president of the Olmsted Brothers landscape architectural firm, had made a total of 14 plans for the grounds of the Capitol for the original Capitol Commission organized by the 1909 Legislature. During the contemporary planning meetings Brown and Hart superimposed the Olmsted Brothers landscape plans on Capitol architect Richard Kletting's designs. The result was the defining event for what would become the governing concept for the Master Plan and for what would become the 21st Century Utah State Capitol. The way forward was clear.

More than 20 architectural and engineering workshops ran in tandem. Budgets were prepared. Schedules were developed. At last, the Board published requests to receive formal proposals from qualified architects and contractor. The construction manager and general contractor, JacobsenHunt, a joint venture group comprised of two

highly experienced firms—Jacobsen Construction Company, Inc. of Salt Lake City and Hunt Construction Group of Scottsdale, Arizona—was the first team member selected for the project.

Together with the Board and the executive director, the construction manager selected the Capitol Restoration Group (CRG) as the architects. The Capitol Restoration Group is a consortium of architects from several firms including VCBO Architecture, MJSA Architects, and Schooley Caldwell Associates.

A construction site for a building the size and complexity of the Capitol becomes a small town complete with a readymade population of thousands of individuals, each with unique expertise and training—architects, engineers, specialized artisans, craftsmen, a public information officer, accountants, office managers, and scores upon scores of skilled laborers. Trailers and temporary buildings in the guise of contractor offices seemed to appear overnight. In addition to the general contractors and architects, this on-site town provided headquarters for more than 150 firms and building contractors involved in the various phases of the project.

Managing the entire project was more like having two or three full-time jobs for Hart, the construction managers, and the Capitol Preservation Board's representative Paul Ernst. Typically they arrived with other section managers on the site before daylight and stayed until the last man left the job. Looking back, construction manager David Marshall has nothing but praise for and pride in the team. "We all here know how lucky we are to be part of such a historic undertaking." As the job neared completion and the hours grew even longer, neither Marshall nor anyone else had a change of heart. Rather like the senior staff of a well-organized army who work to realize a general's vision, a dozen men and women quietly, without a great deal of fanfare, directed the comings and goings of the workforce, the materials, and the supplies. Outsiders will likely never fully comprehend or be able to acknowledge their attention and competent leadership of the project.

From the moment the first shovel of soil was turned, tractors, trucks and other monster-sized equipment came to the site empty and left weighed down with debris and rubble even before the actual Capitol renovation was underway. Several failing structures had to be demolished. The Senate and House Buildings, a central power plant and an underground parking facility were constructed around a newly-designed classical plaza. Tenants of the Capitol planned moving strategies. Every object leav-

# The Utah State Capitol Preservation Board

The 1998 statute creating the Utah State Capitol Preservation Board and subcommittees was written and signed into law in response to recommendations made at the conclusion of a study of the building's structural integrity and the need for affirmative steps to prevent deterioration of its treasures.

The 11-member board, with the governor as its chair, represents not only the legislative, judicial and executive "tenants" of the building but also architects, historians, engineers and other professionals whose collective interest and experience in restoring and maintaining the Capitol Hill Complex was critical to the project's initial and continued success.

In May of 1999, the Board appointed David Hart to be its executive director and the Architect of the Capitol. By statute Mr. Hart, at the direction of the Board, administers the day-to-day operations for the Capitol as well as the other buildings on Capitol Hill and the grounds. He oversees all restoration and construction activities of the project including the installation of base isolators for the protection of the building and its occupants during a seismic event. Trained as an architect and planner at the University of Utah's School of Architecture, he is a member of the American Institute of Architects. He is widely sought after for his expertise in connection with the Preservation Project. Prior to joining the Capitol Preservation Board, Hart was a principal in the architectural and planning firm of Hart Fisher Smith & Associates.

1  David Hart, Capitol Preservation Board executive director

2  Rep. Wayne Harper, Capitol Preservation Board member

3  Sen. Carlene Walker and Rep. Ralph Becker,
   Capitol Preservation Board members

4  Lt. Gov. Gary R. Herbert, Capitol Preservation Board vice-chair

**1**

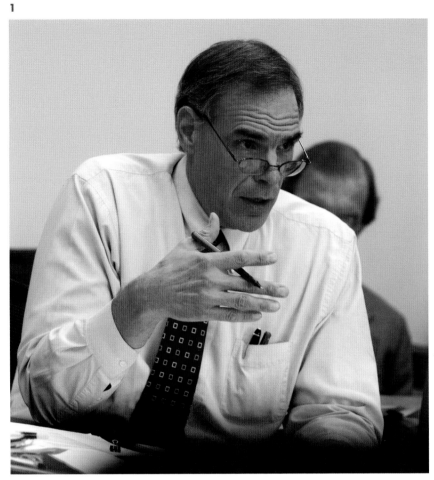

**2**

**3**

**4**

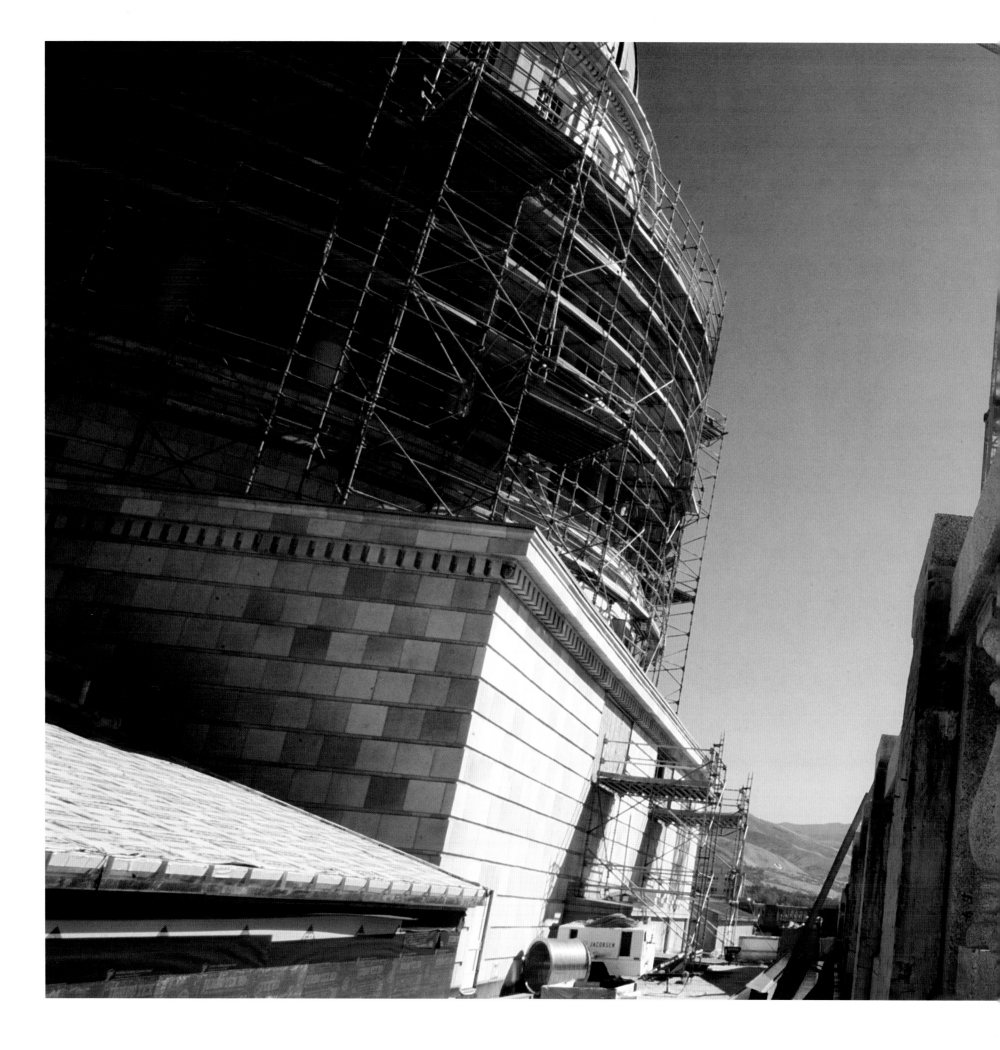

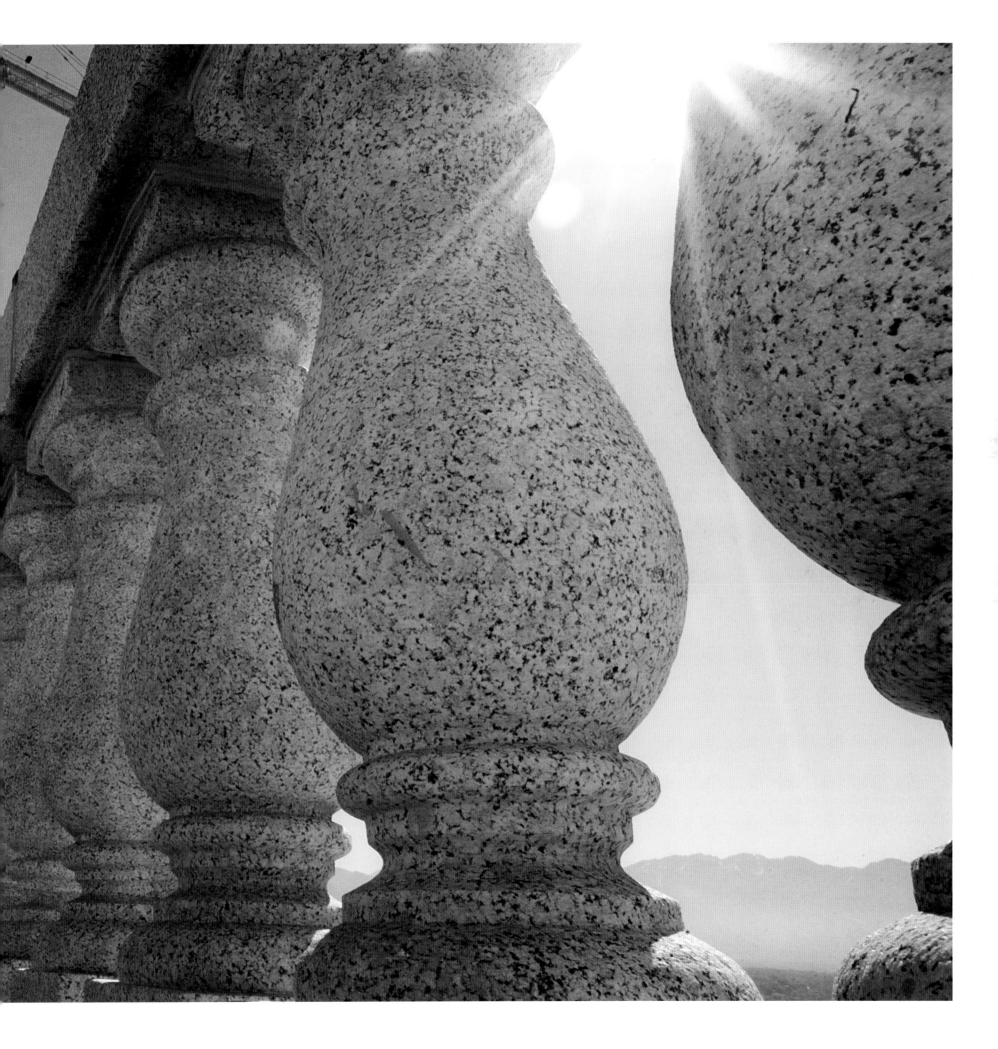

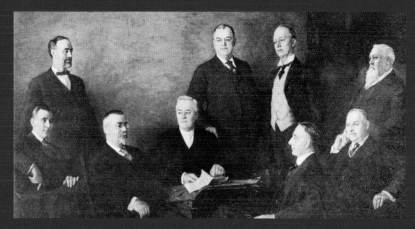

*The Capitol Commission*, a painting by John Willard Clawson, the grandson of Brigham Young. Clawson studied in Paris at the Académie Julian and Ecolé des Beaux Arts (1890-96).

# The Utah State Capitol Commission

**by Richard Tholen**

In 1909, acting as president of the duly authorized Capitol Commission, Utah's Governor William Spry issued the proclamation naming the commission members who would ultimately preside at the 1916 ceremonies opening the Utah State Capitol.

The proclamation began: "WHEREAS, Under the provisions of Section 1, of Chapter 64, Laws of Utah, 1909, the Governor is directed to appoint a Commission to be known as the Capitol Commission . . ." With that preamble, the governor announced the other members of the seven-man Commission:

· Secretary of State C.S. Tingey
· Attorney General A.R. Barnes
· Apostle John Henry Smith of The Church of Jesus Christ of Latter-day Saints and president of the Utah Constitutional Convention in 1895
· Mr. John Dern, banker and leading Salt Lake businessman
· Mr. C.E. Loose, Provo banker and owner of mining and industrial companies
· Mr. M.S. Browning, vice president of Ogden's Browning Arms Company

The Commission appointed John K. Hardy, the governor's secretary, as "Acting Secretary." David Mattson, the newly elected Secretary of State, succeeded C.D. Tingey, and Anthon H. Lund was appointed to fill the vacancy created by the death of John Henry Smith. Upon his release as a member of the Commission, Mr. Tingey was named its secretary.

Beginning in May of 1911, the Commission met regularly for the next seven years to oversee numberless studies and proposals, the selection of an architect and other contractors, the contracts for all participants, and enough acrimonious disputes to satisfy even the most feisty politico. Only four months after the first meeting the Commission published a Program of Competition for the selection of an architect.

The Commission served at its own expense with the exception of the secretary, who received a modest $100 per month stipend. That amount was later increased to $150 per month. Secretary Tingey kept meticulous minutes of the meetings. The record provides a fascinating glimpse into history.

Just two and one half years from laying the cornerstone the Commission was ready for a formal grand opening on October 9, 1916. In the evening a general public reception was held – the guests being received by the governor and members of the Commission in the State Reception Room. The estimated number of guests received at the festivities was 30,000.

The Capitol Commission met for the last time on December 29, 1916, and Secretary Tingey presented its biennial report. Copies of the last annual report, dated January 4, 1917 (when the Legislature convened) were to be bound, prepared and delivered to the members. The minutes of that late December meeting are the last entry in more than 545 pages of commission minutes. They illustrate how diligently the Commission had worked. The Commissioners were faithful overseers of every aspect of Utah's beautiful, new State Capitol.

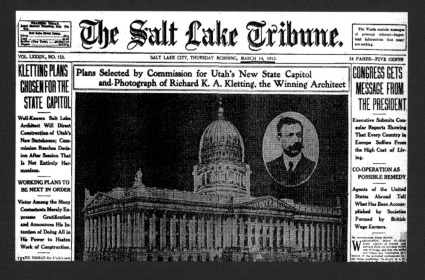

Richard Kletting's selection as architect of the Capitol was announced in local papers on March 14, 1912, ending a year-long competition among many well-known architects. *Historic Structures Report.*

ing the building – including marble panels, wall safes, doors, period light fixtures, furniture, sculptures, and every painting and plaque – was cataloged, photographed and crated for removal to storage facilities or conservation specialists. The Capitol occupants moved into their temporary quarters, and after 92 years of service, the capitol officially closed on September 1, 2004.

Giant cranes began to "fly" enormous palettes of materials to upper floors and to the dome. Inside the building, floors, walls and precious murals were protected. Environmental monitors were set in place to detect potentially damaging fluctuations in temperature and humidity. Demolition crews took out hazardous materials, wiring, entire walls, and even entire floors. The building became a labyrinth of enormous steel beams and scaffolding, inside and out, from the top of the dome down to the basement.

The Board, the Senate and the House commissioned new works of art, and surfaces were prepared for later installation of paintings and sculptures. Electricians, art conservators, plasterers, finish carpenters, craftsmen in a number of vanishing specialties, furniture designers and decorative painters moved about the building. Technology specialists, documentary photographers, and engineers came and went.

Schedulers had reams of charts to refer to daily, which provided line after line of events down to the smallest details, each overlapping and sequencing one another. Reports documenting progress were reviewed and assignments were made as days turned into months that turned into years.

Concurrent with every new phase of construction, safety systems were put in place. Nearly every morning during the construction years, the next new group out of thousands arrived to receive the safety training and screening prerequisite to entering the building from experts charged with the daunting task of keeping every last person entering the site – for long-term or momentary involvement – intelligently out of harm's way, meaning that every individual had to understand the inherent hazards of the project as well as pro-active ways to avoid them.

The terra cotta was a fundamentally functioning historic fabric that had deteriorated over time, and it needed restoration. It was originally installed using popular early 20th-century tools and methods, including ferrous metal anchors, shims, and rods with a brick masonry back-up and cinders for infill. Years of exposure had caused the anchors to rust and corrode, cracking the terra cotta and allowing more water to enter the façade. In fact, some of the terra cotta pieces were no longer even attached to the building due to the extreme deterioration of the anchors. In addition to the terra cotta, many of the rotunda's architectural elements, such as the columns, window hoods, and mid-drum wall portions, were constructed of plaster. The plaster was in worse condition than the terra cotta, with portions of it disintegrating. It was determined that these areas would be clad with new terra cotta, as Richard Kletting originally called for but had been compromised during initial construction due to lack of funds.

Two hundred four terra cotta-clad panels ranging in weight from 800 to 8,400 pounds were installed during this historic renovation and seismic upgrade. Panelized portions of the rotunda drum include the lower balustrade, the upper newel posts, the upper balustrade, window hoods, cornice, and columns. Each radial truss panel is engineered to incorporate both new and restored terra cotta while maintaining the original rotunda drum dimensions and blending harmoniously with the handset terra cotta as well as the pieces never removed.

Thus, the entire dome structure was reinforced with new concrete against an earthquake and brought forward to fulfill its potential. Boston Valley Terra Cotta in New York and Kepco Architectural Cladding Systems of Salt Lake City, both award-winning companies with generations of craftsmen and designers working on the project, made the restoration of the great dome of the building possible.

The most mammoth and all encompassing accomplishment of all, however, one which quite literally dwarfed the others in terms of sheer weight and scope, was the installation of the base isolators beneath every foundation column and the four great rotunda piers.

Within days after closing the building in the summer of 2004, earth movers began to take away tons of dirt and concrete to make way for a second lower foundation to be built beneath the original. This was done in preparation for installing temporary columns, the new foundation, new footings and other complexities associated with what project engineer Jerod Johnson, from Reaveley Engineers and Associates, Inc., Salt Lake City, called a "giant de-coupling strategy." Reaveley Engineers teamed with Forell/Elsesser of San Francisco on the structural design of the base-isolation system.

In June of 2006, crews began installing the first base isolators—cylindrical devices consisting of laminated layers of rubber and steel plates that surround an energy-absorbing lead core. Manufactured by DBI in Reno, Nevada, the isolators range from 34 to 44 inches across and are about 20 inches tall. Harris Rebar from Salt Lake City built the rebar-intensive beam transfer systems under each of the four massive rotunda piers.

"We basically uncoupled the building from the ground," said Johnson, "without moving the building" by dividing its entire weight by the number of foundation columns and great rotunda pier supports, temporarily shifting that weight onto new columns, installing base isolators on the foundation columns, and then shifting the weight back to the isolated columns. Such a calculated do-si-do was repeated more than 285 times until in May of 2007, with a collective sigh of relief and more than a few smiles from the group surrounding the last isolated column, the base isolation system was formally put into service. The accomplishment is an extraordinary one. The numbers alone are staggering: 400 to 800 thousand pounds per each column, 10 million pounds per rotunda pier. Upon completion, the entire building (measuring 320,000 square feet) is now capable of "gently" rocking back and forth as a whole up to 24 inches in any direction rather than shaking apart during a seismic event of a magnitude of up to 7.3 on the Richter scale.

The base isolation phase of the project is unique in the entire world. An appropriate reference from Greek mythology comes to mind but with a contemporary twist. The base isolation of Kletting's building is rather like employing Atlas, the titan in Greek mythology who was temporarily condemned to hold the disk of Father Sky on his shoulders in an attempt to forestall his marital embrace with Mother Earth. The twist in this metaphor is, of course, that in this case Atlas was consigned to bear his heavy load even as workmen went about literally knocking the ground from beneath him while simultaneously fitting his many feet with giant shock absorber sneakers.

## A Reverence for Kletting

For everyone working on the once-in-a-lifetime opportunity, the enormity of the project was nearly always accompanied by another realization about the Capitol restoration project. It concerns the project planners' deliberate yet enlightened devotion to Utah architect Richard Kletting's original vision. Several examples serve to illustrate that idea. The first has to do with interior design.

Architectural designers and historians from the Capitol Restoration Group, including architects Rob Pett, Sean Onyon, Karen Ferguson and Charles Shepherd, combed the building as well as years' worth of original documents for clues and "left behinds" in order to understand the conditions they faced. Their need was to confirm the diagnosis of the Historic Structures Report and to monitor their ailing patient. Together with other consultants they spent days and weeks that turned into months comparing correspondence, drawings, and plans (as well as photographs made during original construction by Harry Shipler's photography studios) in order to make judgments about decorative trims, fabrics, carpets, and fixtures. Historic furniture was identified, collected and restored and, in cases where unique objects no longer existed, reproductions were made with every facet compared to original records for accuracy. Details measuring no more than fractions of inches were considered.

Highly specialized conservators entered the scene early in the process as a first step in bringing the building back to the original palette and designs. They took samples from every part of the structure for computer-assisted spectrum and chemical analyses. Once layers of paint and grime were separated into color types and the original colors were determined, several hundred color matches were mixed and Evergreene Painters, a New York-based firm specializing in restoration of historic interiors, went to work applying the colors and gold leaf, brushstroke by brushstroke. Visitors to the newly-restored building will find dazzling colors, brilliant gold leafing effects, and decorative stencil moldings throughout the Capitol that honor the original designs.

The second example of keeping faith with Kletting's design is the newly built south terrace. While the tendency in recent decades, in any number of additions to neoclassical buildings of the same era as the Capitol, has been to add more modern structures – the Kevin Roche John Dinkeloo glass wing expansions of the Metropolitan Museum come to mind – the decision in Utah was unequivocal: find ways to finish the building as it was initially conceived. Kletting's competition rendering showed a grand terrace and ceremonial entrance for the governor on the west and south sides of the building. A terrace surrounding a building was a fairly typical solution for leveling uneven ground on a site.

---

1   The 20-year Master Plan for the Capitol Complex was inspired by the original drawings of John Olmsted and Richard Kletting. The plan includes the cherry tree-lined oval path and the proposed new State Office Building.

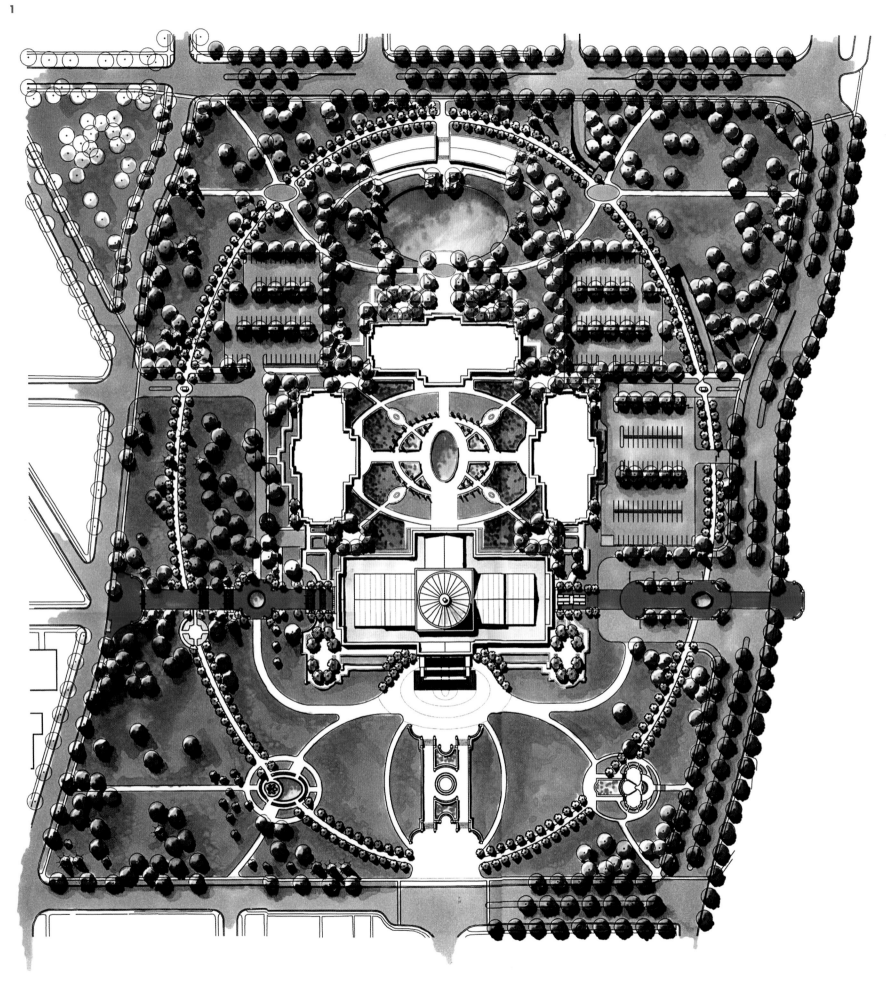

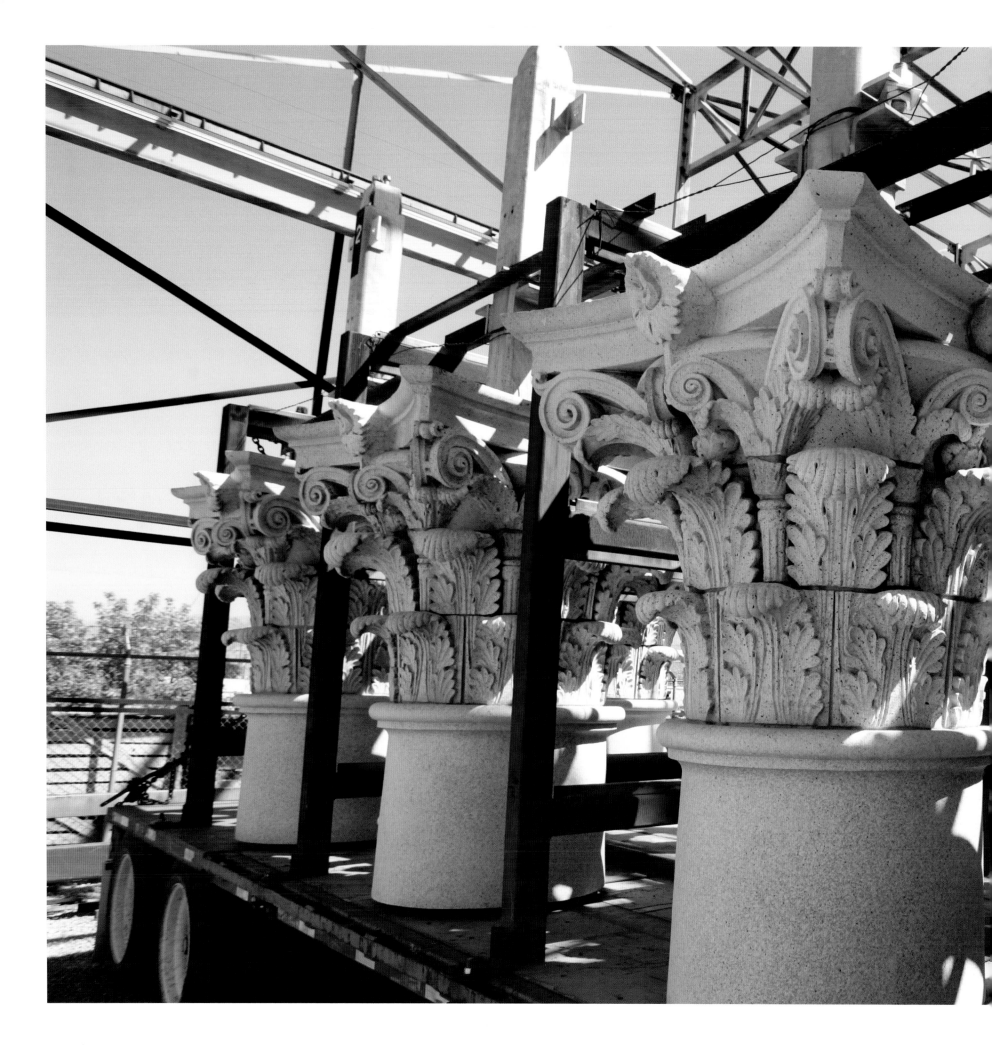

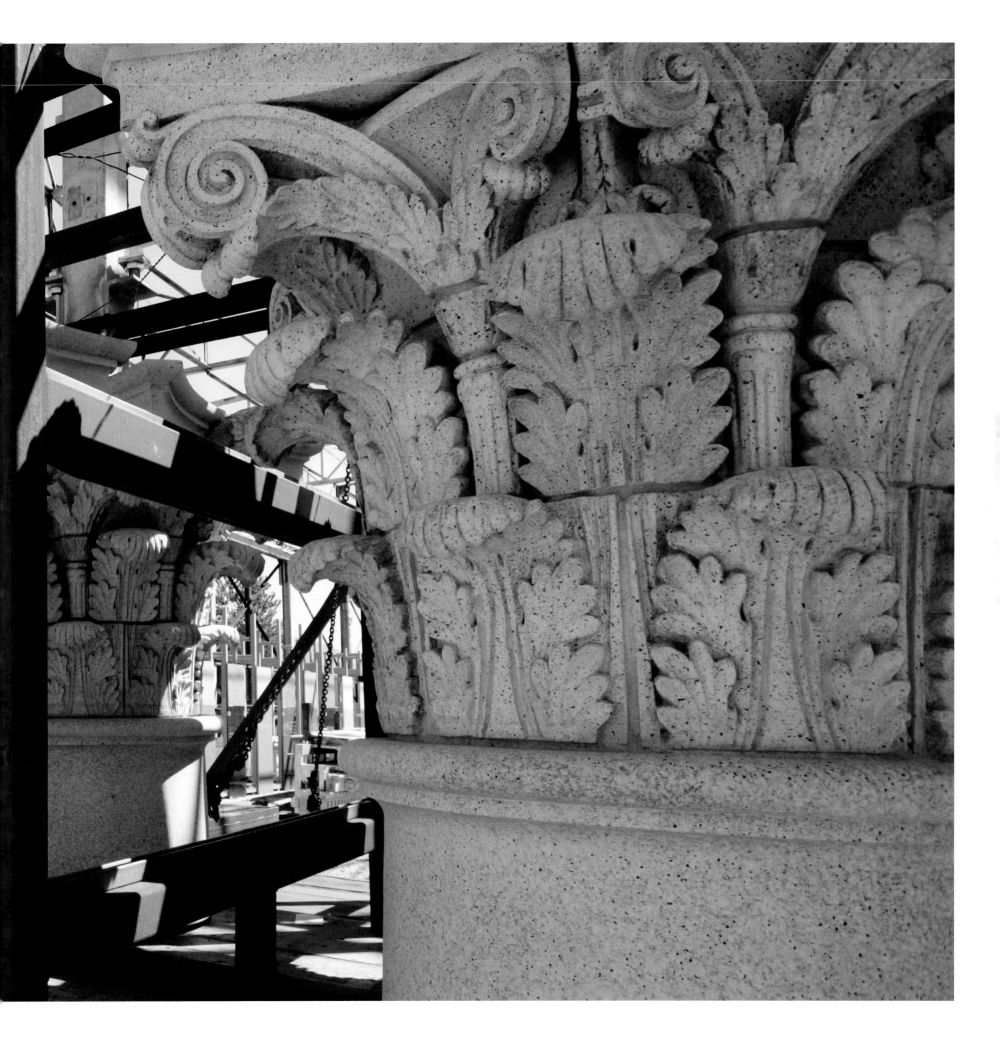

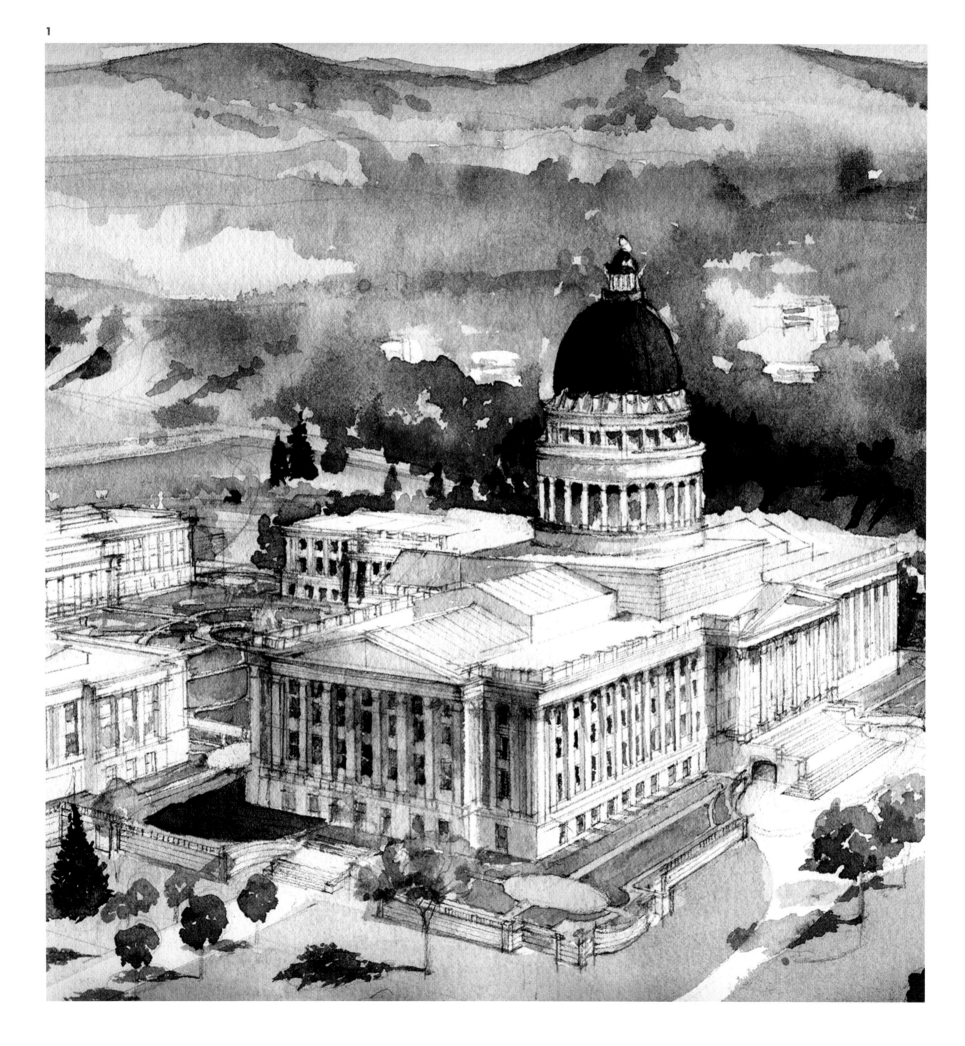

Only a letter from a contractor addressed to the original Capitol Commission provided some general outlines of and reference to that part of the rendering for the architects. But there were some functional reasons for adding the terrace in the contemporary project: office space lost to base isolation in the lower levels of the building needed to be recaptured; modern security, mechanical and electrical issues needed accommodation. Nevertheless, visitors to the restored Capitol will see the new terrace, essentially indistinguishable from the one Kletting drew into his original proposal.

A final example relates to the art planned for the building. During the construction of 1912 to 1916, the original Capitol Commission had to return to the Legislature on two different occasions to ask for additional funding for the building's completion. The Capitol Commission had saved a considerable amount of money in the process of construction despite contemporary allegations to the contrary. Regardless of every effort to maintain quality within a limited budget, funds to finish the building and install the art simply could not be found. However, murals, sculptures and other works of art were definitely not an afterthought for Kletting or the Commission. In fact, no respectable public structure of the day would be without appropriate sculptural ornament. The very idea of a Beaux Arts design without sculpture inseparably connected to the architecture would have been unthinkable. In addition, because of the intimate connection between art and architecture in the style, any sculpture would of necessity feature appropriate subjects as well as style and materials. Kletting's correspondence with the most notable Utah artists of the day details his wishes for narrative sculpture programs for the exterior pediments and the interior drum frieze. Moreover, Kletting showed at least four acroteria, or sculptures, on each corner on the roof.

The Commission's correspondence argued for figures representing abstractions like Agriculture, Liberty, Mining, or Justice to be completed as part of the building rather than as an afterthought. It is significant that the Philip Dern Decorating Company, in writing its proposal for the interior design contract, specified murals to be placed in designated spaces in the House, Senate and Supreme Court Chambers as well as the ornate State Reception Room ceiling and the half-circle lunettes at either end of

---

**1**  Project definition architect Paul Brown made a series of watercolor paintings, including this oblique view of the complex, visualizing the scope of the Capitol restoration project.

# The Shipler Photographs
## of the Utah State Capitol Construction

Four generations of Shiplers took photographs of Salt Lake City and the Great Basin. James Wilson Shipler (known as J.W.) arrived in Utah in 1890. He was 41 years old. He had left parents and a wife in Pennsylvania in 1872 and for the next 18 years made extended stops in Denver, Montana and finally Utah in pursuit of a fascination with accounts of life in the West.

J.W. opened his commercial photography store on Main Street and First South in 1903. For the next three quarters of a century the Shiplers – father, son, grandson and great grandson – operated the business under a motto J.W.'s son Harry (who merged his competing business with his father's in 1909 and subsequently managed the company) wrote as a caption on promotional photos: "I go anywhere to photograph anything."

Harry secured a contract as the official photographer of the Utah State Capitol construction in time to document the groundbreaking ceremonies in 1912. The Shipler Commercial Photographers Collection, or simply the Shipler Collection, contains more than 100,000 glass negatives and prints of remarkable quality documenting every aspect of life in the Great Basin generally and Salt Lake City in particular. After James' great-grandson William Hollis closed the retail store in 1988, the collection was donated to the University of Utah. The Utah State Historical Society provides access to Shipler's superb visual essay of the original Capitol construction; the Utah State Capitol website has a link to the photographs. A pictoral biography of the Shipler family, by archivist Allen Barnett with a forward by former Salt Lake City mayor Ted Wilson, called *Seeing Salt Lake City: The Legacy of the Shipler Photographers* was published by Signature Books in 2001.

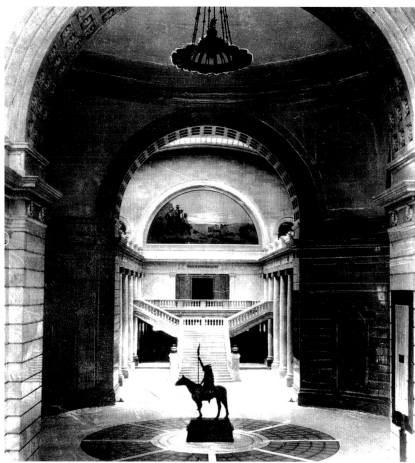

the grand atrium space. Finally, the rotunda was to feature four murals in the four pendentive spaces and four sculptures in the niches below. Only a portion of the art program was completed by the time the building was dedicated in 1916.

Even though the plans do not officially specify the subjects for the niche sculptures, research confirmed that the final Capitol Commission report of 1916 admonished its readers that the building must contain the art components to be complete. And, based on a wealth of information about style (as well as actual documents expressing the desire that the Commission wanted to model Utah's building after recently completed buildings such as the Kentucky and Minnesota statehouses that have niches for monumental sculptures) the architects knew that Utah's four pier niches were to feature allegorical subjects appropriate to the building's style, use and purpose. Planners decided that additional ornament and art must be further declarations in paint, marble or bronze about the state's aspirations and values.

That very-much-warranted assumption produced a number of challenges for the Capitol Preservation Board of 2000 which had worked tirelessly to establish an entire volume of important guidelines and imperatives for the project that included the third imperative – that the Board would preserve the "historical and architectural integrity" of the 1916 Capitol.

First, it was obvious that even though the original Capitol Commission ran out of money prior to completing the intended (if not mandated) sculptural decorations, future additions must correspond to their intentions. Second, it was equally obvious that the sculptures in the niches would need to be reconsidered in light of the third imperative of the Historic Structures Report to restore the original Capitol, including its art program. Finally, when the building closed in 2004 the Capitol Preservation

**1**  The Shipler photograph of the Utah State Capitol rotunda, circa 1917, features a finished lunette mural and a sculpture by Cyrus Dallin. The four niches Kletting intended to be filled with monumental sculptures are empty. *Utah State Historical Society.*

**2**  Sculptors Eugene Daub (left) and Jonah Hendrickson (far right) and Capitol Architect David Hart compare the plaster maquette of *Land and Community* to the full-scale dense foam model of the 11-feet bronze niche sculpture.

Board and the support staff needed to move quickly to complete whatever sculptural program was commissioned in order to meet a 2008 re-opening deadline.

Contemporary planners and subcommittees charged with art placement in the restored building examined Kletting's intentions by way of the letters and documents. They came to know what the earlier groups had wanted. They also knew that even the twice-honored additional requests for money from the early Legislatures could not fund the art phase of the project. Times had been hard and, from the perspective of the present day, would become even more difficult for more than one reason after the completion of the building.

At the time the Capitol was dedicated in January of 1916, the Nation would soon join the First World War. The State was, by-in-large, populated with people of humble means or little cash. Consequently, although mining and railroad barons had become the Capitol's donors and art patrons, early photos of the rotunda show empty niches until 1928. In that year, the "women of the state" gifted the Capitol's northwest niche with a life-sized marble portrait bust of writer and leading suffragist Emmeline B. Wells by Cyrus Dallin. Then in 1943, a bronze bust of Simon Bamberger, Utah's governor from 1917 through 1921, by T. S. Knaphus was placed in the southwest niche. In 1980 the family of Maurice Warshaw, a "pioneer in the development of supermarkets" (quoting from the plaque on the base), gave the state a second marble bust by Avard Fairbanks.

The first and only monumental figure to appropriately fit the niche proportions is Utah State Senator Dr. Martha Hughes Cannon, elected in 1896 as the first woman elected to a state senate in the United States. The eight-feet tall bronze sculpture by Laura Lee Stay was installed in the northeast niche in 1997.

Regardless of either the artistic merit and/or historic importance of the individuals memorialized in the niches or the artists who created them, the predicament for the preservation planners was two-fold: Three of the four were not large enough for the space and all were portraits of specific persons rather than metaphorical creations as the original documents seemed to demand.

The solution was, by all accounts, generous and fitting. Senator Cannon presides in the foyer of the new Senate Building where the sculpture can be seen in the round. The other sculptures will be properly installed in the restored galleries of the Fourth Floor, spaces once used by the Utah Art Institute for annual exhibitions.

As for the niches, with the Preservation Board's approval, the Art Placement Subcommittee (first organized by Utah County Rep. Jordan Tanner) established four allegorical titles for the new works addressing specific Utah ideals and values. A national request for proposals from the country's best sculptors was published.

The new works, which are monumental in scale and also fitting for the spaces and the Beaux Arts style of the building, are bronzes created by Eugene Daub, Rob Firmin, and Jonah Hendrickson.

The cumulative effect of this new and conserved art in the rotunda is greater than merely decorating the blank spaces and volumes. The new niche sculptures will continue to speak to future generations and visitors about what citizens of Utah consider to be of lasting importance; yet they also honor Kletting's love of classical harmony, balance and proportion – that very Greek concept of *arête*. These new works remind every visitor and tenant of the building of its importance to the children of our children's children. In a very real sense, the sculptures represent the State's noble past as well as the hopes and dreams for its future.

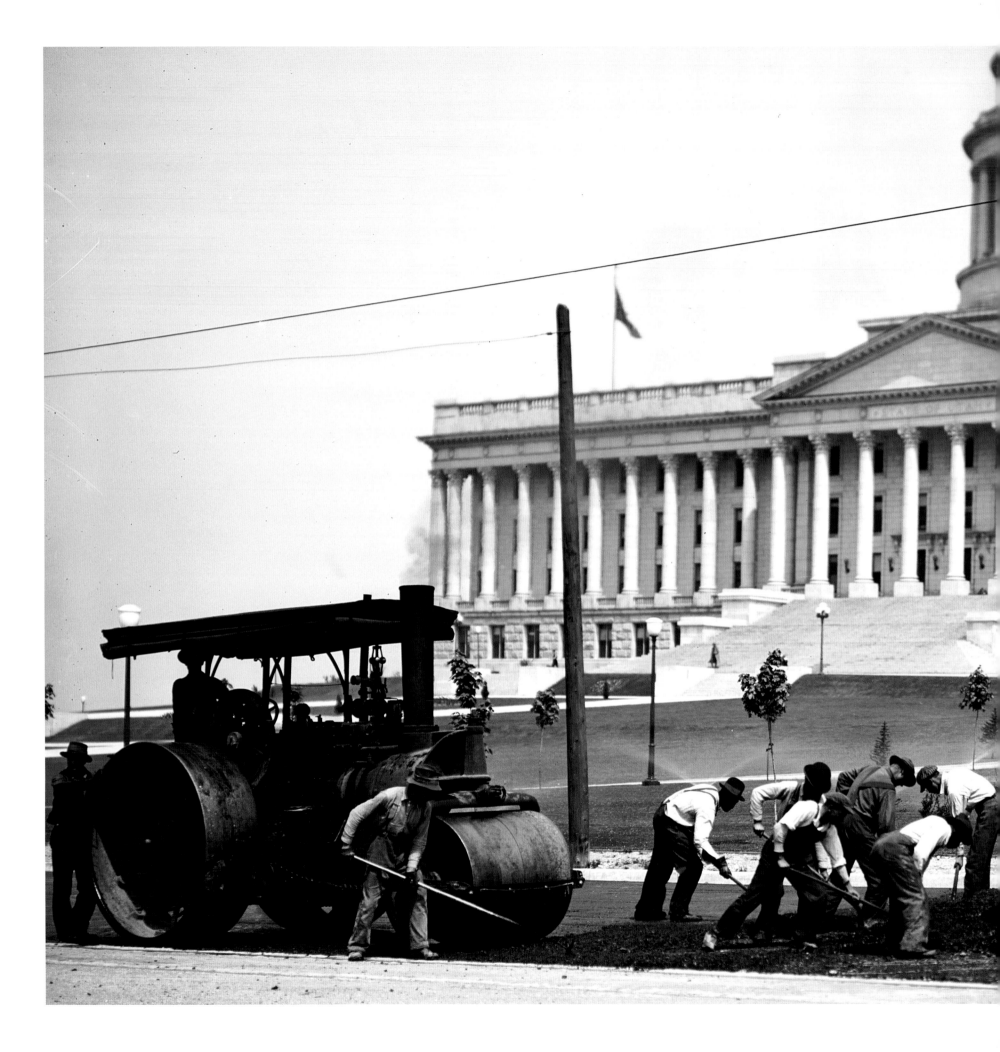

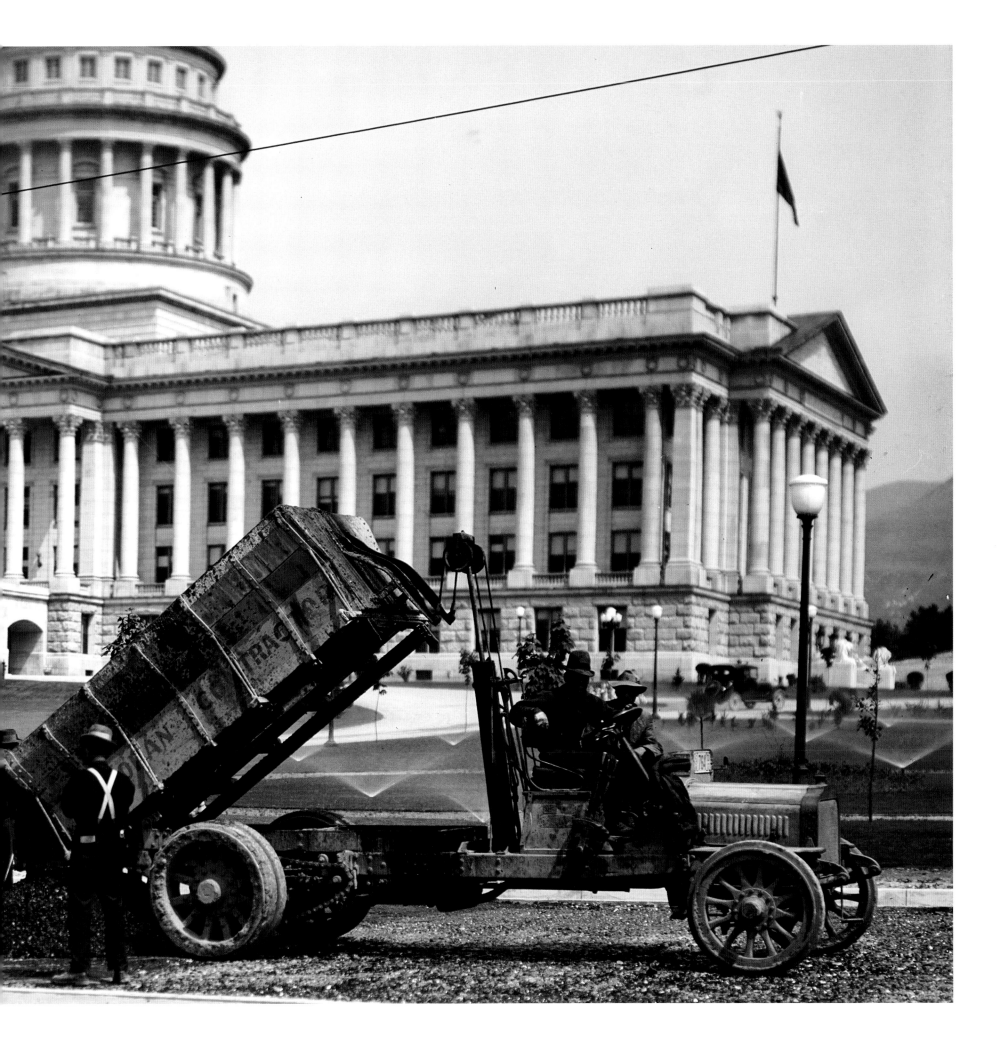

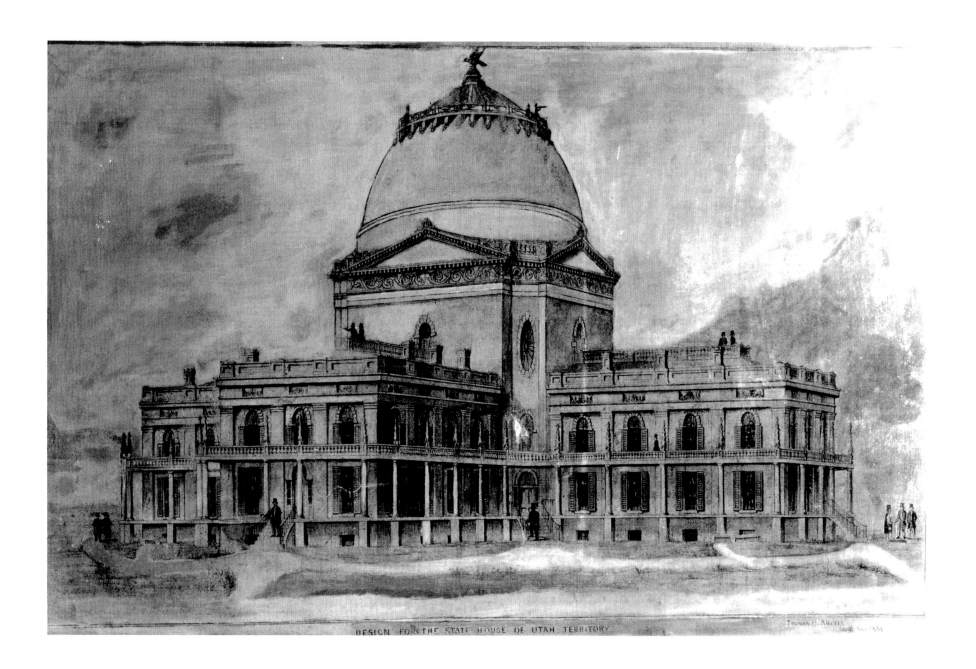

DESIGN FOR THE STATE HOUSE OF UTAH TERRITORY

**LEFT**  An early rendering of the proposed capitol in Fillmore, Utah, designed by Truman Angell. Only one wing of the building was eventually completed. *Historic Structures Report.*

# Kletting's Capitol

# 2

## The First Attempts

The tiny Utah town of Fillmore, in Millard County, was named after the thirteenth president of the United States. During his tenure in office between 1850 and 1853, President Fillmore had presided over the creation of what the Mormon pioneers had wanted to call Deseret, an enormous expanse of the West including not only the land of present-day Utah but also parts of what would later become Arizona, Nevada, California, Idaho, Wyoming, Colorado and New Mexico. Congress greatly reduced the borders and officially named it the Utah Territory after one of the larger Native American tribes roaming the Great Basin.

Within a few years after territorial status was accomplished, however, it became apparent that the decision to make the isolated little community of Fillmore in the middle of the territory into its capitol city had been problematic. In 1856, after meeting for just one session in the partially completed territorial capitol designed by Truman Angell, the Legislature moved itself 130 miles to the north to the obviously more advantageous city referred to as the "Crossroads of the West." As the new capi-

tal designate, Salt Lake City was trail's end for thousands of immigrating pioneers, miners, and entrepreneurs. Trade, commerce and industry thrived in the city and surrounding towns due in no small part to the fact that by 1869 the transcontinental railroad had linked the Utah Territory to the east and west coasts and beyond.

Congress had appointed Brigham Young as the first territorial governor. He remained in office until 1857. For the next 33 years the territory's governors were shipped from the East in rapid succession. Most came reluctantly and temporarily to a place thought to be on the other side of nowhere. As elected officials and leading citizens argued for and eventually achieved statehood, the Legislature met in borrowed quarters in Salt Lake City, all the while planning for eventual construction of a building of sufficient gravitas to nobly house the three branches of a proper state government.

For 60 years, the territorial and later state legislatures met in at least five different buildings around the city including Council Hall (built in 1866 and restored and relocated in 1961 to its present site just south of the Capitol); the County Courthouse, the first City Hall, the Women's Christian Industrial Home (all demolished in the last century); and the Romanesque revival-style City and County Building (built in 1894

43

on land eight blocks south of the Capitol Hill Complex and restored over a ten-year period ending in 1989).

Salt Lake City had long held ownership of 20 acres of land only a short distance north of the center block of the city. Known as Arsenal Hill, the property was bordered on the east by a steep drop-off with a snow-fed creek and mature cottonwood trees at its bottom. The hill provided a spectacular view of the wide valley to the south, the Wasatch Mountains to the east and the Great Salt Lake to the west. In 1888, the city deeded the property to the territory for the construction of a suitable capitol.

## The Capitol Commission and New Resolve

In 1909, thirteen years after Utah became the 45th state in the Union and 21 years after the state acquired the Arsenal Hill property, the Legislature provided for the creation of a seven-man Capitol Commission and empowered and directed the group to see to building a capitol. The ultimate cost of the project from start to finish was not to exceed $2.5 million, a colossal sum of money for the day and for the state. (In today's currency, the allocation would exceed $75 million.)

In order to fund a project of that magnitude the Legislature authorized a special election to allow citizens to approve a one-mill levy assessment on personal income. The election was needed to raise the funds because years earlier the state had used the $1 million from the federal government to construct the territorial statehouse, and the federal government refused to provide additional funds. The election failed. Apparently the citizens of Utah thought the state government could wait a bit longer to have such an extravagant permanent home. For the next two years, all plans were on hold until on March 1, 1911, Mrs. E. H. Harriman, widow of one of the state's most prosperous railroad magnates, settled her husband's estate by making a check to the state treasurer for $798,546. With such a windfall in state coffers, the Legislature matched the Harriman estate taxes with a $1 million bond. The Capitol was to become a reality.

By August of 1911 a program of competition for the selection of an architect for a state capitol was announced. The Commission narrowed a long list of interested firms to a qualified few and entertained proposals from architects both in and out of Utah. Speaking for the Commission, Governor William Spry finally announced that the proposal of renowned Salt Lake architect Richard Kletting had been selected. Kletting would collaborate with landscape planning consultant John Olmsted of the Boston landscape architectural firm once directed by John's father, the famous Frederick Law Olmsted. Frederick was the designer of New York's Central Park and was part of the team selected to design the most successful world's fair ever, the great Chicago Columbian Exposition of 1893. Local newspapers published the decision of the Commission with enthusiastic headlines and copy praising Kletting by calling him the "Dean of Utah Architects."

By December 26, 1912 plans were sufficiently complete for excavation to begin. The Commission held a groundbreaking ceremony at the site. Salt Lake City Mayor Samuel Park addressed the assembled, frozen crowd with a text that must have had particular poignancy for many. "We are about to realize the hope of decades and the fruition of the efforts of patriotic citizens for a quarter of a century," he declared. "[W]e break ground for the material edifice that shall house the offices of our chief executive, our legislative and judicial bodies. The time has been long and we have waited and labored in patience, but the reward is now certain, for the means are available and the people have decreed that in this place a house shall be built which, for its purpose, shall be one of the most beautiful as well as one of the most modern of public buildings in the world." He continued that Utah's "greatest problem [was] to provide means so that the governmental functions may keep pace with the growth of our population and business enterprises. It [had] long been the regret of the inhabitants of this state that we have had no adequate place of this kind…" (Minutes, 1912)

## Three Reasons for Richard Kletting's Design

The Salt Lake City and County Building stands eight blocks south of Richard Kletting's classical Utah State Capitol. Once the meeting place for the state's

---

**1** The view from Arsenal Hill (later Capitol Hill) looking south shows downtown Salt Lake City and the uncompleted Salt Lake Temple. *Utah State Historical Society.*

**2** Mary Harriman, widow of railroad magnate E. H. Harriman, made a check to the State for $798,546 to settle her husband's estate. The amount provided the initial funding for the construction of the Capitol. *Historic Structures Report.*

**3** Kletting's early site plan served as partial inspiration for the modern Master Plan. *Historic Structures Report.*

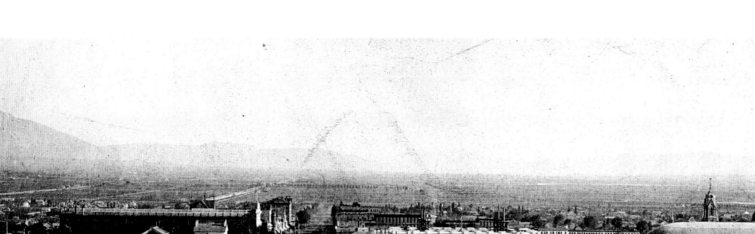

1

2

No. 119      New York, March 1 1901

**Guaranty Trust Company of New York**
28 NASSAU STREET

Pay to the order of David Mattson Treasurer State of Utah —

Seven hundred ninety eight thousand five hundred forty six & 85/100 Dollars

$798,546. 85/100

Mary W. Harriman

EXECUTRIX

3

BLOCK PLAN
SCALE 16

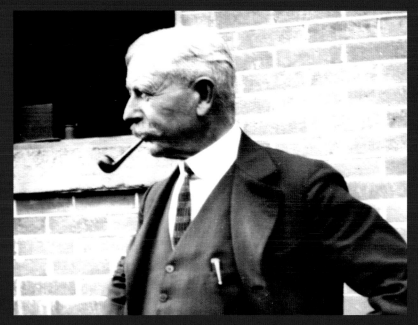

Richard Karl August Kletting, Architect of the Capitol

# Richard Karl August Kletting

**1858 – 1943**

Most tourists make lists of must-see things at the places they visit. In New York, it would be the Empire State Building and the Statue of Liberty. In Texas, everyone wants to see The Alamo. Today a visitor's list for Utah would include the national parks in southern Utah, perhaps the Winter Olympics venues, and arguably Utah's most famous urban attraction, The Church of Jesus Christ of Latter-day Saints Temple Square.

But at the beginning of the 20th century in Utah a must-see list would have been a different one. Certainly Temple Square would still be there. A bit later in the century the huge open-pit copper mine in Bingham Canyon would undoubtedly have made the list. But in 1916, two other buildings on the list drawn by any self-respecting tourist (or for that matter resident) were both designed by the man known as the "Dean of Utah Architects"—Richard Karl August Kletting. The buildings bracket his professional life in Utah.

The first was the original Saltair Resort, located on the southeast shore of the Great Salt Lake. In the early 20th Century it was by far and away the most popular attraction around. And at the height of its relatively short life, more than half a million people came each year to bob about in the lake, ride the giant rollercoaster, attend performances of traveling vaudeville companies, and most important of all, dance on what was advertised as the world's biggest dance floor. Kletting completed the design for the ornate structure within only months of his arrival in Utah in 1892 at age 34. After soaking in the architecture of Paris, the young Kletting had decided to immigrate to America

in 1883. He spent the next nine years making his way west. Saltair opened in 1893, the same year the imposing Salt Lake Temple was dedicated by Mormon Church President Wilford Woodruff. Saltair burned to the ground in 1925.

The last and crowning achievement of Kletting's distinguished career came at the end. At 54 he was among 40 other architects who submitted plans for the new state capitol. Stunning in its scope and proportions, the Beaux Arts classical revival structure draws upon the vocabulary of the United States and Texas State Capitols so popular in turn-of- the-century America. The construction materials—terra cotta and reinforced concrete—made the building an example of truly modern concepts in architecture.

Kletting's other achievements have become some of Utah's beautiful private mansions and businesses, including the Enos Wall mansion on South Temple Street (formerly the home of LDS Business College), the McIntyre Building on South Main Street and Salt Lake School District's Oquirrh School. After Kletting's death in September of 1943, the state legislature named a 12,000-foot peak in Summit County in his honor.

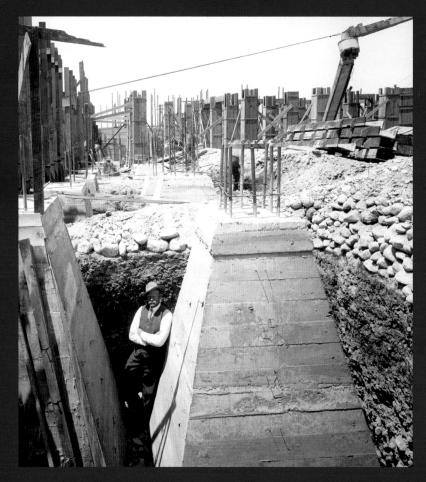

Kletting inspects one of the original footings for the Capitol.

Supreme Court as well as the temporary home of the Territorial Legislature, the City and County Building was completed in 1894. It was designed by the architectural firm Monheim, Bird and Proudfoot (Monheim being the only Utah resident) formed specifically for the project. The building is typical of the exceedingly popular style of the late 19th century. Labeled Richardsonian Romanesque after the American architect Henry Hobson Richardson who promoted the style, it is built with heavy rusticated local sandstone blocks emphasizing rounded turrets and corner towers surmounted by sculptures representing the city's virtues. It has an irregular façade with a dominant center clock tower, and above all, heavily ornamented rounded arches reminiscent of 12th century Romanesque cathedrals.

Conceived and dedicated just 15 years before the Capitol Commission began its work, the City and County Building's design is poles away from Richard Kletting's winning design for the Capitol. Not only have the color of the stones but also the details of the two structures become a study in contrasting architectural styles, the contrasts are also symbolic of changing times and attitudes in Utah history.

The gap of only a few years between the City and County Building's construction and the beginning of the Capitol's was a time of convergence of attitudes and events related to the state's history: Utah had been admitted to the Union after a long, acrimonious struggle and the ability to finally build a capitol. The mood of the country as a whole concerning public and government building projects was changing. The 1893 Chicago Columbian Exposition dramatically influenced architecture, landscaping and city planning throughout the country.

America was in the midst of an age of grand museum and public building construction. Beginning in the last decade of the 19th century and continuing for the next 40 years, most major and aspiring cities in the country—including New York, Chicago, Boston, Philadelphia, St. Louis, Washington, D.C., Brooklyn, Cleveland, San Francisco and, of course, Salt Lake City—engaged in important construction projects to organize and beautify urban centers, to collect and exhibit symbols of democracy and the nation's past, and to present for public enrichment the current prosperity and culture of the nation.

A 1913 book by Edwin Blissfield on mural paintings and public art is typical in expressing the hope that great and uplifting art and architecture would "embellish" not only every home but also "every city." The nation's best art would and should be "where it belongs, at the top [of cultural expression], in a public building of a design sufficient to express not only America's illustrious past but also its claim to a heroic future." In fact, the race by city fathers, including Salt Lake City's, to put their municipalities on the cultural map with public art collections and building projects was so widespread that those years have been consistently called The Museum Age, when "marble civic palaces" were commissioned at a remarkable pace.

There are a number of social and economic reasons for the intensity of American interest in the construction of buildings to house the workings of governments as well as the collections of art and history-related objects. First, in the last decades of the century the country had rapidly become one of the leading industrial giants among nations. The most obvious consequence of success was that such a robust, albeit speculative and erratic, economy increasingly brought a concentration of wealth to a few individuals who became the patrons of the arts and public works projects.

By the turn of the century, wealth, rather than birth, had become the great determiner of American social standing. With wealth came a collective sense of responsibility, a sort of capitalist's *noblesse oblige*, to educate the less well-off masses in American history, culture and art. Many of Utah's leading and most wealthy citizens held and promoted that view. Mayor Park's speech at groundbreaking ceremonies for the Capitol reflected the national view: "At this place a house shall be built," he declared, "[that] shall be one of the most beautiful as well as one of the most modern of public buildings in the world . . . so that the governmental functions may keep pace with the growth of our population and business enterprises."

The sentiments of Utah's Superintendent of Schools D.H. Christensen also seem to be typical of the times. In a debate about the design of the new state capitol he wrote that the plan should feature the "most beautiful things in the world" for the benefit of the children of the state. And if the legislature could not fund the acquisition of the objects of beauty, the wealthy mining magnates who built mansions along South Temple could and should.

The second reason for interest in public art and building projects nationally as well as in Utah was related to the burgeoning industrial cities that were ever more populated by an impoverished immigrant labor force as well as with rural Americans who migrated to urban centers seeking greater economic opportunity. Few of the new urban poor had much education. Suitable places for whatever leisure time the laborers had would have a salutary effect on the city's criminal elements. New buildings

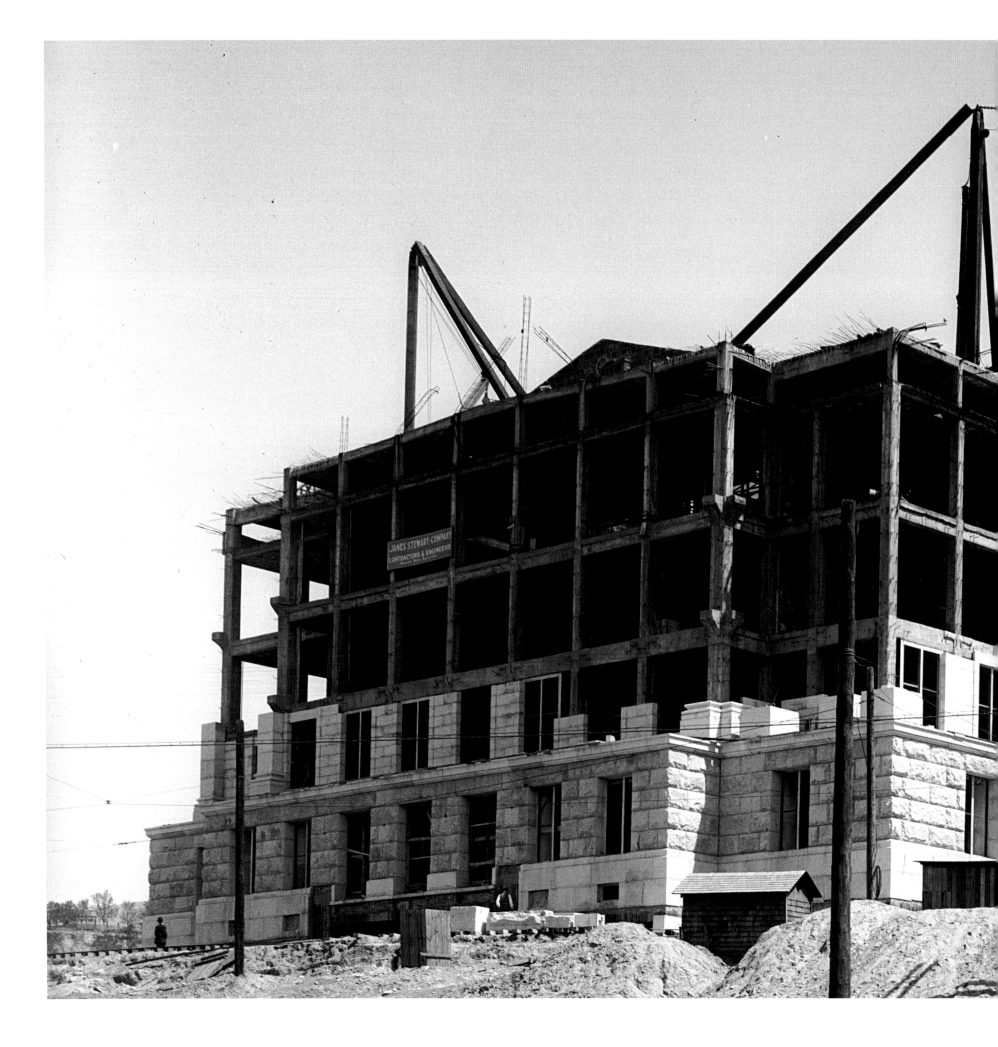

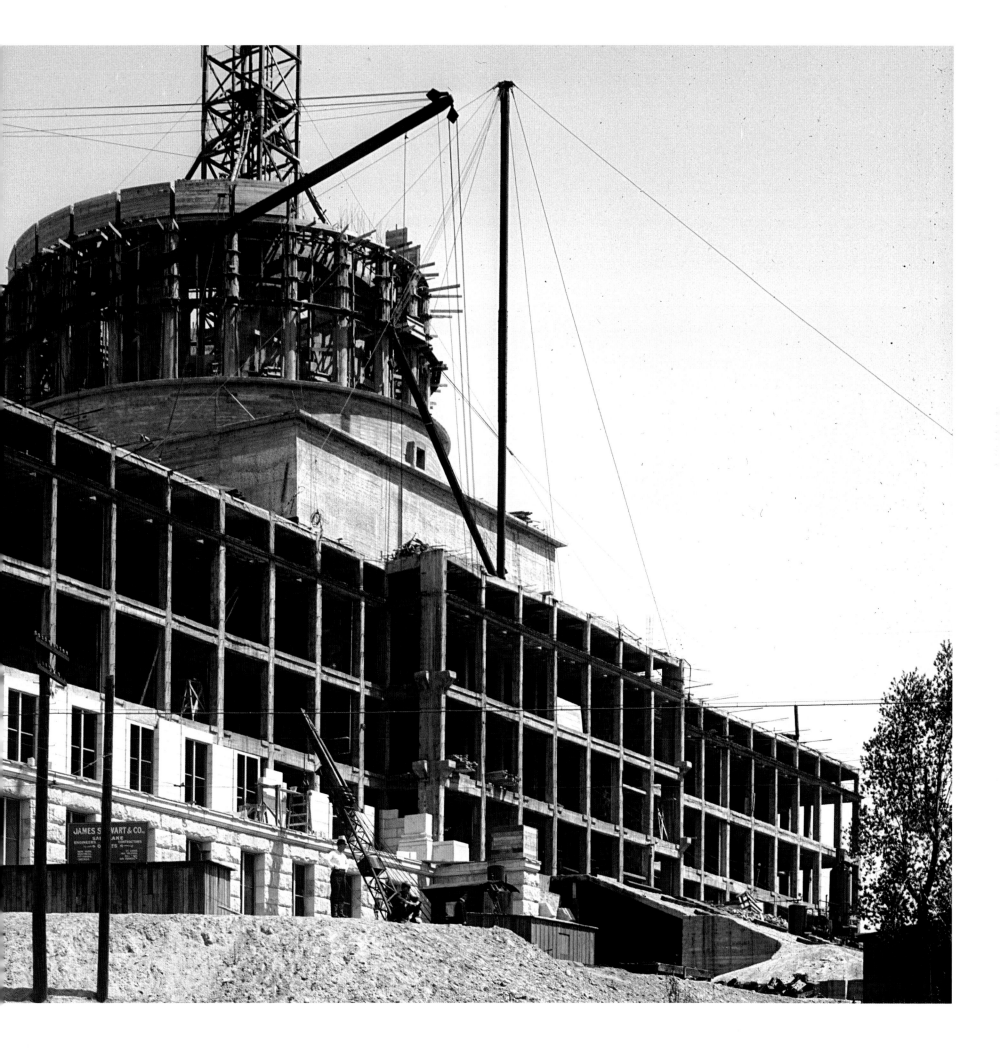

Souvenir Program

FORMAL OPENING
UTAH STATE CAPITOL
OCT. 9, 1916

OPENING EXERCISES, 2 P. M.
RECEPTION AND DANCING, 8 P. M.

and beauty could be socially ameliorative, not to mention inspiring. All were combined to create a boom for new building commissions like Kletting's Utah's State Capitol.

The highly influential British critic John Ruskin may not have been the first to call the results of the public bricks-and-mortar boom—the buildings and their decorations—Temples to Democracy or Temples to Art, but he may have been the most well-known individual to do so. Nonetheless, Ruskin observed that these "palaces of study and high contemplation" were the age's manifestation of "perfect order and perfect elegance." Furthermore—and this is an extremely important point as it relates to the contrast between the Salt Lake City and County Building and Kletting's design for the Utah State Capitol—it was the growing general consensus over a period of 40 years, from about 1890 to 1930, that the language and vocabulary of the so-called temples and their contents ought to be based on a revival of Greek ideals and styles via the Renaissance.

The revival of those styles was best expressed through the enormously influential classical curricula in painting, sculpture and architecture of the French Ecolé des Beaux Arts, or School of the Fine Arts. France was at the zenith of its authority over Western art and culture. In calling for public art in classically designed structures, as opposed to the earlier Romanesque styles of Salt Lake's City and County Building, citizens and Americans of "class" regularly followed France by constructing buildings in what was universally referred to as the Beaux Arts style.

would provide inexpensive places for public instruction by means of exhibit cases filled with objects important to the history of a particular place.

Finally, in an atmosphere that saw the United States, not to mention Utah, as backward and uncultured, the American ethos of nobility-by-wealth sought ways to establish cultural standing both at home and abroad. A certain Elmer I. Goshen, writing to Utah's Capitol Commission on the issue of monolithic columns for the new building, reflects typical American sentiment toward the state and the nation proving itself to others: "Utah has the greatest opportunity," he said, "for doing the distinctive thing in art and in architecture...unique in the history of the country [and] *in the world* (italics added)." These combined motives for patronage and construction have been variously described as "patriotism, prestige, and pleasure through moral elevation."

This critical mixture of wealth, an urban labor force, a sense of social obligation to children and the poor, and a desire for status at the beginning of the 20th century, added to a quasi-religious conviction—particularly strong in Utah—that symbols of civil order

**1**  The Utah delegation to the Chicago Columbian Exhibition of 1893 stands at the front entrance of the Utah Building. The territorial exhibit included a replica of Salt Lake City's Eagle Gate. *Utah State University Collection.*

**2**  The Richardsonian Romanesque-style Salt Lake City and County Building was home to the Utah State Legislature prior to the opening of the Capitol. *Historic Structures Report.*

**3**  The Utah delegation stands in Jackson Park near the impressive man-made lake designed by Frederick Olmsted. The entire Chicago Fair's grounds inspired later city park planning in major cities across the United States. *Utah State University Collection.*

**4**  Workers in the granite quarries of Little Cottonwood Canyon, located 20 miles southeast of Salt Lake City, pose for Harry Shipler's documentation of the original Capitol construction. *Utah State Historical Society.*

**1**

**2**

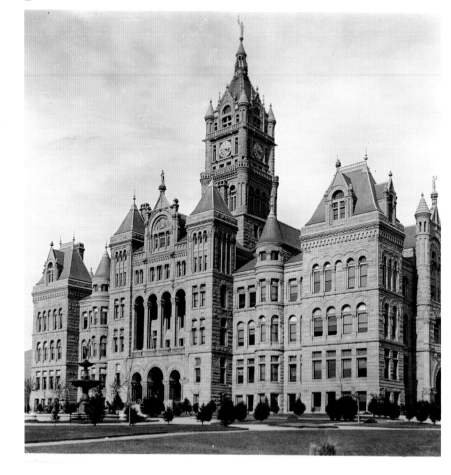

**3**

**4**

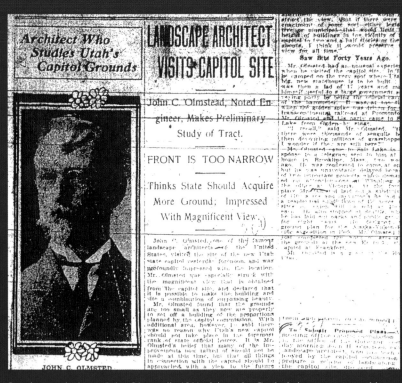

Landscape designer John Olmsted's 1911 visit to the Capitol site was reported in city newspapers. *Historic Structures Report.*

# John C. Olmsted
## and the Legacy of Urban Park Planning

Daniel Burnham, the genius behind the World's Columbian Exposition of 1893 (more often referred to simply as the Chicago Fair) called the landscape architect for New York's Central Park and the wildly successful Chicago Fair, Frederick Law Olmsted, an artist who painted "with lakes and wooded slopes; with lawns and banks and forest-covered hills; with mountain-sides and ocean views . . . " History professor William Wilson (1989) articulates what virtually all his colleagues who study American architecture and urban design have recognized: Landscape architect Frederick Law Olmsted left a legacy of incalculable importance to nearly every municipal center in 19th century America, whether in small towns or large cities.

First, he changed the discourse about city parks or town squares from a focus on the park itself to a consideration of entire comprehensive, multi-purpose systems. Second, he argued that "aesthetic improvements" to streets, pedestrian walkways, transportation systems, and leisure centers had a restorative influence on the people who experienced them. In effect, beauty made us better. Third, Frederick Olmsted left a thriving landscape planning consulting practice to his sons and stepson. Known as the Olmsted Brothers landscape planning firm, they in turn were enthusiastically retained by more than 200 cities and towns throughout the country in the early 20th century as consultants and specialists for practical civic improvement and beautification. The Olmsted brothers' mission was manifestly to proliferate their father's legacy, to create urban parks and landscapes using four basic elements: public access, grand vistas, formal layouts and neoclassical architecture.

John C. Olmsted was Frederick's stepson and nephew. His mother, the widow of Frederick's brother John Hull Olmsted, married Frederick shortly after her husband's death. John C. was reared as if he had been Frederick's biological child. He entered Olmsted's architectural firm after graduation from Yale and later became its managing director and standard bearer after his father's retirement in 1893.

The firm's many clients were scattered throughout the United States from coast to coast. That meant months of travel for John who was described as a fastidiously dressed, introverted aesthete with a neatly trimmed beard, who was capable of not simply maintaining the legacy of his famous parent but rather establishing a genuine and permanent point of view about professional consulting.

John C. first came to Utah in 1869 at the age of 17 with Frederick to attend the Driving of the Golden Spike ceremonies. He was invited to Salt Lake in 1909 but did not come to consult with the Capitol Commission on the Utah project until 1911. He explained to the *Salt Lake Tribune* that other, more major, projects in California, Seattle and Washington prevented his trip to Utah. During his short stay in Utah he proposed solutions for problems at the site on Arsenal Hill. Later, the Olmsted Brothers firm drew 14 plans for the project. Capitol architect David Hart and planning expert Paul Brown used those drawings to formulate the contemporary Master Plan (see page 33) for the Capitol preservation project.

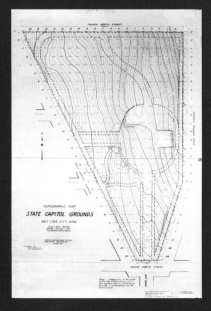 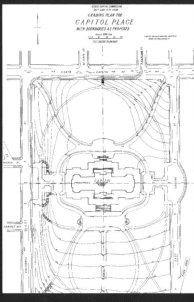

A contour map (left) shows the original awkward funnel-shaped grounds plan of the proposed Capitol. The 1912 Olmsted Brothers plan (right) includes the oval walkway, which became a guiding element in the development of the 2007 20-year Master Plan. *Historic Structures Report.*

In selecting Kletting's classic design, Utah's Capitol Commission was signaling its intent to enter the progressive, enlightened community of states and cities of America and the world.

The nexus between French neoclassicism and the Capitol's architectural program is visually and philosophically direct via Richard Kletting's experience and training in Paris prior to coming to Utah as well as the country's mood in general. Heavy Romanesque revival-style buildings were rapidly being left behind by American architects for more so-called "enlightened" expressions of the ancient world's ideals of governance and power. Those symbols included post and lintel construction methods, the addition of large volumes of interior light-filled spaces, a good deal of classic Greek and Roman symbols, formal symmetry, giant entry staircases and porticos topped by triangular pediments, and proportions described as the ideal shapes—known as "golden" or "perfect" rectangles and squares. Any visitor to the restored Capitol cannot miss how Kletting incorporated virtually all those features in multiple permutations and combinations throughout the building.

A second connection to Beaux Arts classicism runs westward from France through Chicago and the Columbian Exposition. Today we can hardly imagine the influence of the Exposition on 19th-century America. It opened in May of 1893 and closed only six months later. During that time, however, more than 27 million people paid to see its attractions, this in a country with a population of just over 65 million. The Fair gave the nation innovations that are now taken for granted in modern society, things as common, comic or compelling as the zipper fastener, exotic "belly" dancers, AC current for conducting electricity, the trolley car for mass transit, the concept of a "midway" of rides, treats and attractions now obligatory at state fairs across the country, and the Ferris Wheel (invented by George W. Ferris as a response to Gustave Eiffel's elegant iron tower built for the Paris Exposition of 1889).

By all accounts, however, the crowning achievement of the Chicago Fair was not the showcase of the newest scientific and technological advancements, but rather the architectural design and park planning that signaled the beginning of the resurgence in America of academic neoclassical styles and the somewhat short-lived City Beautiful Movement. The Columbian Exposition of 1893 not only changed American architecture but also quite dramatically shaped official views on style and the inclusion of art and culture curriculum in public education and civic dialogue.

By the time the gates of the Fair closed forever, the host city, or "Hog Butcher to the World" (a reference to Carl Sandburg's 1916 poem celebrating Chicago), clearly led the way in the Beaux Arts movement, at least until Chicago architects Louis Sullivan and Frank Lloyd Wright brought modernism to the nation.

The entire Fair was designed by a team led by the brilliant Daniel Burnham, landscape architect Frederick Law Olmsted and renowned sculptor August Saint Gaudens. Other architects are among the Who's Who of 19th century designers. Many of the more than 200 buildings for the Fair were temporary steel and timber structures built to house exhibits representing the country's achievements in industry, mining, agriculture, arts and culture. The Fair also featured exhibits from 19 countries and 38 states. The expanse of Fair buildings, known as White City, had few permanent structures. Buildings that were converted or built to last in the first place remain, in effect, the placemaker structures, parks and public art of Chicago, just as the parks and capitols in cities like Washington, D. C., or states like Texas and Utah are in their respective locations.

The rest of the country, including Utah, got in step with the sensibilities of the Fair's White City. Chicago had realized that its future economic vitality was tied to a new identity as a cosmopolitan center. Like so many other cities at the 19th century's end, Chicago and its upper class had embraced their new roles as patrons of the arts. The goals of "patriotism, prestige, and pleasure through moral elevation," expressed through the city's collections, education institutions, and bricks and mortar, became the driving ideals that led immediately to capturing the celebration of the 1893 Columbian Exposition for Chicago in new structures throughout the country.

## The Utah Connection

A number of architectural histories and accounts of the Chicago Exposition draw rather explicit lines between the Chicago Columbian Exposition of 1893, the arts, architecture and turn-of-the-century American culture. It becomes apparent that there was an understanding (as in an assumed consensus) at the time, perhaps still held by many today, that properly designed public buildings are innately possessed of a type of metaphysical power. A woman referred to simply as Mrs. Brand of San Diego, California, expressed a typical sentiment when she wrote to the Utah Capitol Commission in 1915 that "a building [such] as your state capitol is not for the present,

# Alice Merrill Horne

Alice Merrill Horne is the matriarch of the art collection in the restored Utah State Capitol. She was elected from the Eighth District of Salt Lake City in 1898 at age 30 and thus became the second woman to serve in Utah's state government. During her tenure in the House, Rep. Horne was the author and sponsor of House Bill 124, legislation passed in 1899 creating a state art institute. The official title was "A Bill for An Act to Provide for the Creation of a State Institute of Art, and Prescribing its Manner of Appointment, Powers and Duties." Reported to the full House of Representatives from the Committee on Education, Horne's bill was expressly not only for visual arts but also for music, literature, and dance and public education in the arts. Horne was to champion public education in the arts her entire life.

But in 1891 Horne was only a very young 23 year-old, newly married woman who had made considerable local art connections when she was appointed to chair the Utah Liberal Arts Committee which was charged with planning for the Territory's entry in the upcoming Chicago Columbian Exposition of 1893. She saw and toured the new Chicago Art Institute building, né The World's Congress Hall, during the Fair.

She wrote about the 1899 Art Bill in a 1914 "handbook" for Utah Art. She wrote about how appropriate neoclassical architecture was for Utah's Capitol with an undeniable reference to the Chicago Fair's designs. In a direct reference to the Art Bill she said that "[t]he state institution for the encouragement of the fine arts, comprising, according to law, an annual art exhibition, a state [public] collection, a course of public lectures on art and an annual prize of $300 for the best painting (to become part of the Alice Art Collection) (sic) was created by the Third Legislature." She added, obviously with some justifiable pride in accomplishment, that Utah "was the first state to create an art department at state expense."

In later years Horne came to be known as Mother Alice. She was 80 years old when she died in 1948.

but for the future generations. [It is an] open book in which the younger ones can read the story of efforts and sacrifices of early comers, and resolve that in love of country, faithfulness, fidelity and honor as citizens, promoters of all that is excellent, they will at least equal their predecessors" and citizens in Europe.

Alice Merrill Horne was a 23-year-old educator with promise in 1891 when she was appointed to chair the Utah Liberal Arts Committee of the Chicago Fair. She made extensive notes and illustrations of her experience in Chicago. At the end of the Fair, Horne returned to Salt Lake City and to a population in the midst of the bitter fight for statehood. She and the other members of the Fair delegation received appropriate accolades. Less than three years later, Utah celebrated its admission to the Union as the 45th state. The first and second Legislatures convened. By 1898, Horne was an elected representative from Salt Lake City's District Eight. From that seat she worked to pass legislation that in turn influenced the Capitol Commission's decision to include in the official 1911 "Program of Competition" document, which Richard Kletting responded to with his brilliant winning plans for a Beaux Art Capitol, a list of office spaces required to be shown in the competition drawings. The list included a board room and an art gallery for the education and betterment of the people of the state.

In Horne's auspiciously titled book, *Devotees and their Shrines: A Handbook of Utah Art*, published in 1914 during the height of construction of the Capitol, she wrote an essay on notable Utah architecture. In it she opined on the appropriate neoclassical architecture of Utah's Capitol with an undeniable reference to the Chicago Fair's designs.

---

**1**  A Harry Shipler photograph features wooden truss forms for concrete walls and arches of the rotunda. *Utah State Historical Society.*

**2**  The ceremonial south entry boasts colossal order granite columns. The Capitol Commission entertained a movement to replace the 52 exterior segmented shafts with monolithic polished marble columns, creating a heated debate in the capital city. *Utah State Historical Society.*

**3**  The Capitol's imposing interior columns in the atrium vaults are polished monolithic marble. *Utah State Historical Society.*

**4**  A wooden crane lifts heavy elements used in the construction of the reinforced drum supporting the dome. *Utah State Historical Society.*

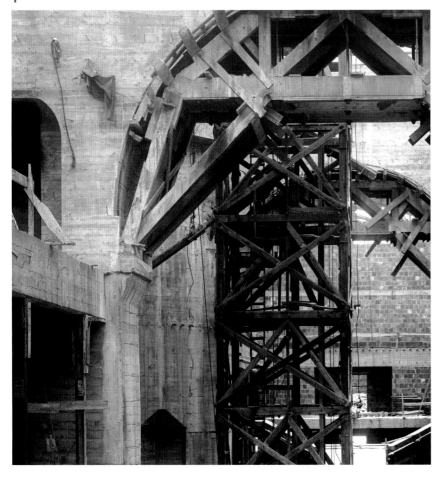

1

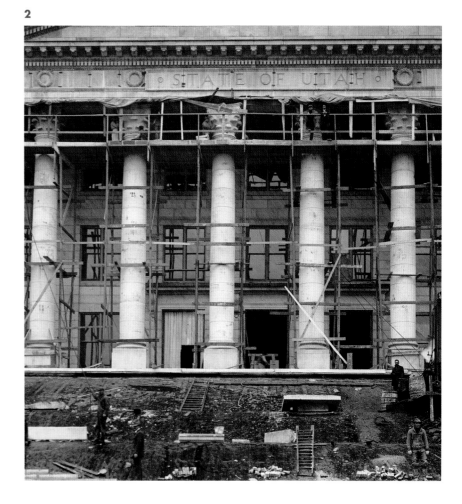

2

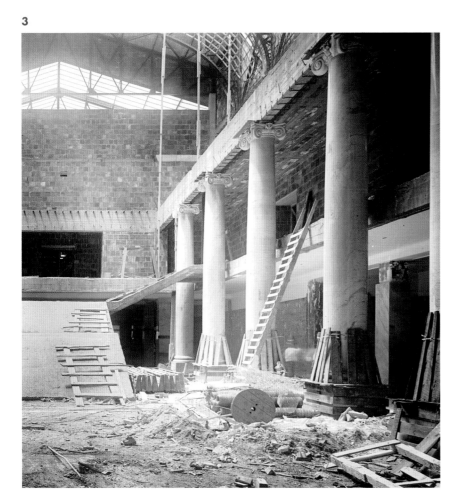

3

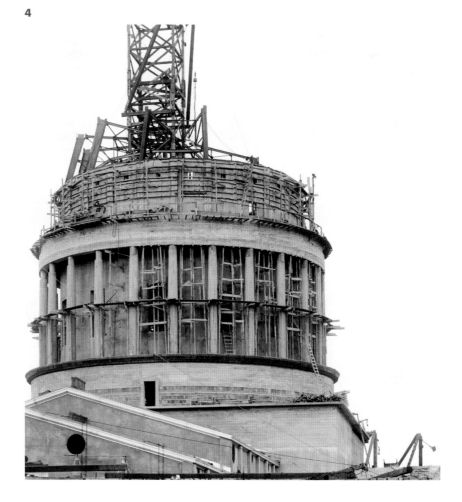

4

## Completion and Dedication

Before construction on the Capitol began, both the Capitol Commission and Kletting researched and visited other capitols around the country with the intent of borrowing the most useful design concepts and integrating them into the Utah Capitol plans. As a result, exterior facades, the dome, the office layouts, and decorations are reflective of other state capitols.

Kletting also borrowed from publications on classic orders and ornaments published for 19th century architects. He depended heavily on William Ware's *The American Vignola: a Guide to the Making of Classical Architecture* for detailed drawings on columns, capitals, moldings, and ornamentals. Ware founded America's first schools of architecture in 1865 and 1881 and published what came to be referred to simply as the "vignola" (a reference to Renaissance architect Giacomo Vignola's guide to classical Greek architecture), a textbook for his classes at Columbia's School of Architecture. The text was written in response to the unprecedented demand for designs and mathematical formulae used by the architects of the Beaux Art classical revival movement largely begun at the Chicago Exposition. Ware's extensive knowledge of Beaux Art architecture came from his mentor Richard Morris Hunt, the first American student of the French Ecolé des Beaux Art and Architecture.

From the base of the building to the top of the interior dome, Utah's Capitol is 404 feet long, 240 feet wide and 285 feet tall. Kletting's design was the only plan submitted that proposed mammoth freestanding columns on three sides of the building. The Commission and Kletting specified the use of native Utah materials and custom-designed ornamental features. Kletting altered many of Ware's templates by adding distinctive symbols of Utah. The columns, along with the rest of the exterior, are constructed of Utah granite (technically a monzonite material) taken from Little Cottonwood Canyon in Salt Lake County.

Kletting's vision took two and one-half years to build. Even so, many of the details, even large sections of the design, were never built. Time and money constrained the Commission's efforts. But on October 9, 1916, at precisely 2:00 p.m., invited guests and dignitaries gathered to celebrate the completion of the Capitol on the same spot Mayor Park had announced the intentions and the hopes of the city and the state. The Mormon Tabernacle Choir provided the musical program, including a rendition of "Utah We Love Thee" and a solo performance of "Columbia, the Gem of the Ocean" by the choir's director. Governor Spry, acting in both roles as the governor and the president of the Commission, spoke. There is no complete record of what he said. It is likely that the assembled crowd inside the rotunda and outside on the still barren grounds reveled in the extraordinary accomplishment of a young, growing state.

1   Twenty-four architectural firms from throughout the country were invited to submit plans for the Utah State Capitol design competition. The runner-up in the competition, Young & Sons, offered an ornate, flamboyant plan—a stark contrast to Kletting's simpler, classic design. *Historic Structures Report.*

THE·LAST·STONE·FOR·STATE·CAPI
81·DAYS·AHEAD·OF·CONTRACT·800·CAR·LOADS·UTAH·GRANITE·MADE·I
CONSOLIDATED·STONE·

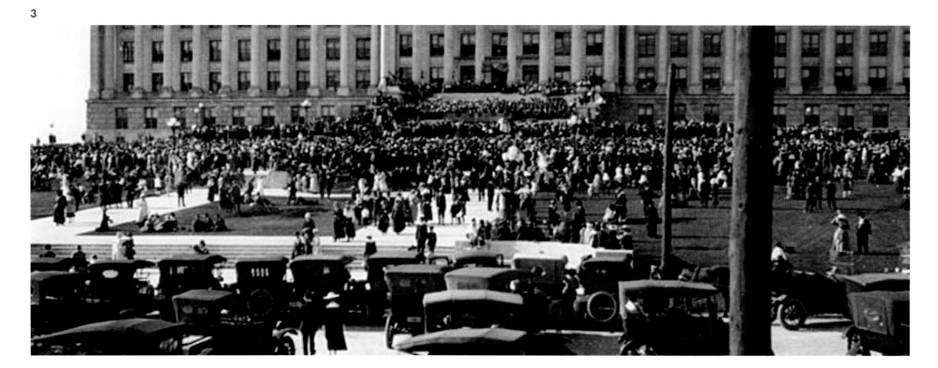

**1** Richard Kletting, pictured with his wife and children, was selected as the Capitol Architect in 1912. In a *Salt Lake Tribune* story, Kletting stated that his selection was ". . . an honor of which any one in my profession might well be proud." *Utah State Historical Society.*

**2** Governor Spry, Richard Kletting and the Capitol Commission celebrate as the last stone from 800 carloads is set in place on the south façade. The cornerstone celebration took place nearly three months ahead of schedule. *Utah State Historical Society.*

**3** An estimated 30,000 jubilant citizens showed up on October 8, 1916 at 2:00 pm for the dedication and grand opening of the Capitol. *Utah State Historical Society.*

Philip Dern advertises his company while his workers paint the Gardo House. The home, owned by wealthy miner and art patron Edwin F. Holmes, was located just across from the Beehive House on the southwest corner of State Street and South Temple. *Utah State Historical Society.*

# The Philip Dern Decorating Company

If seeing is believing, then the Philip Dern Company found the optimal method of advertising the special services they offered in early 20th-century Salt Lake City. Dern's banner, along with his painters and other craftsmen, prominently shows the company's assets and upscale clientele in a Harry Shipler photo of the Gardo House on South Temple Street taken at nearly the same time as the Capitol was being constructed on Arsenal Hill.

Philip Dern founded the decorating company that would come to make a proposal of far reaching significance to the State of Utah. Dern became part of the ensemble of architects, builders and designers for the Capitol in 1914 with a proposal that included not only the interior wall surfaces, plaster ornamental moldings, gold leaf and decorative trims throughout the building now restored as part of the Capitol preservation project, but also murals for the legislative and judicial chambers, the governor's formal reception room and the rotunda dome. In language typical of the entire proposal, Dern "suggested" the "ceiling of the rotunda . . . will be painted to obtain clouds and sky with the suggestion of sea gulls flying. This bird is very characteristic of Utah and a very interesting effect can be obtained."

The Dern contract included hiring two New York City artists for the House Chamber. Vincente Aderente and A. B. Forringer painted the murals on site according to the specifications of the contract.

## The Columns Controversy of 1914

According to the records of the Capitol Commission, what came to be known simply as the Column Controversy was about two things: the use of Utah materials and the cost of making a change in the Capitol's design. Certainly those factors were of immense importance to the taxpayers and the Commission whose membership represented various important constituencies of the state. There was also a sense that honorable contractual arrangements, the ethics of the situation, meant the Commission could not alter either Kletting's plan or the contractor's and subcontractors' binding contracts.

Local architects protested the changes for various reasons: Perhaps some of the Utah architects remained rooted in the Richardsonian model for civic building design. In that aesthetic, segmented columns were of minor importance. Perhaps added expense of a change was a factor. Perhaps Utah product suppliers had won the day. And it is entirely possible that the Utah architects were simply in support of their own "Dean of Utah architecture," Richard Kletting. Whatever the reason, they wrote an official objection to the move for monolithic columns.

The Columns Controversy was a significant enough argument that local papers took up the issue on editorial pages. And Junius Wells wrote and published a pamphlet representing citizens and professionals who passionately wanted to see the 52 colossal order columns running along three facades of the building to be monolithic and polished.

Most of the arguments in support of the change were about making the building a showpiece to the world, making Utah respectable in the eyes outside the state and the country. A few got at the heart of the matter: It was not about strength, cost, or Utah materials. It was all about appearance. But what was the standard to which the columns were to be measured? The answer could be that with the tastemakers of the country preaching the absolute superiority of classic revival building design as proper symbols of power and democratic ideals, Utah could not compromise and fail to measure up. It would, in the protester's eyes, be very much like dressing a grand lady in fake jewels.

Whatever the reasoning—stated or implied— the Commission voted to continue construction as planned. The columns we see today are 52 segmented, unpolished (but without fluting) colossal order columns with Corinthian capitals directly from William Ware's textbook drawings for Greek and Roman classical architecture.

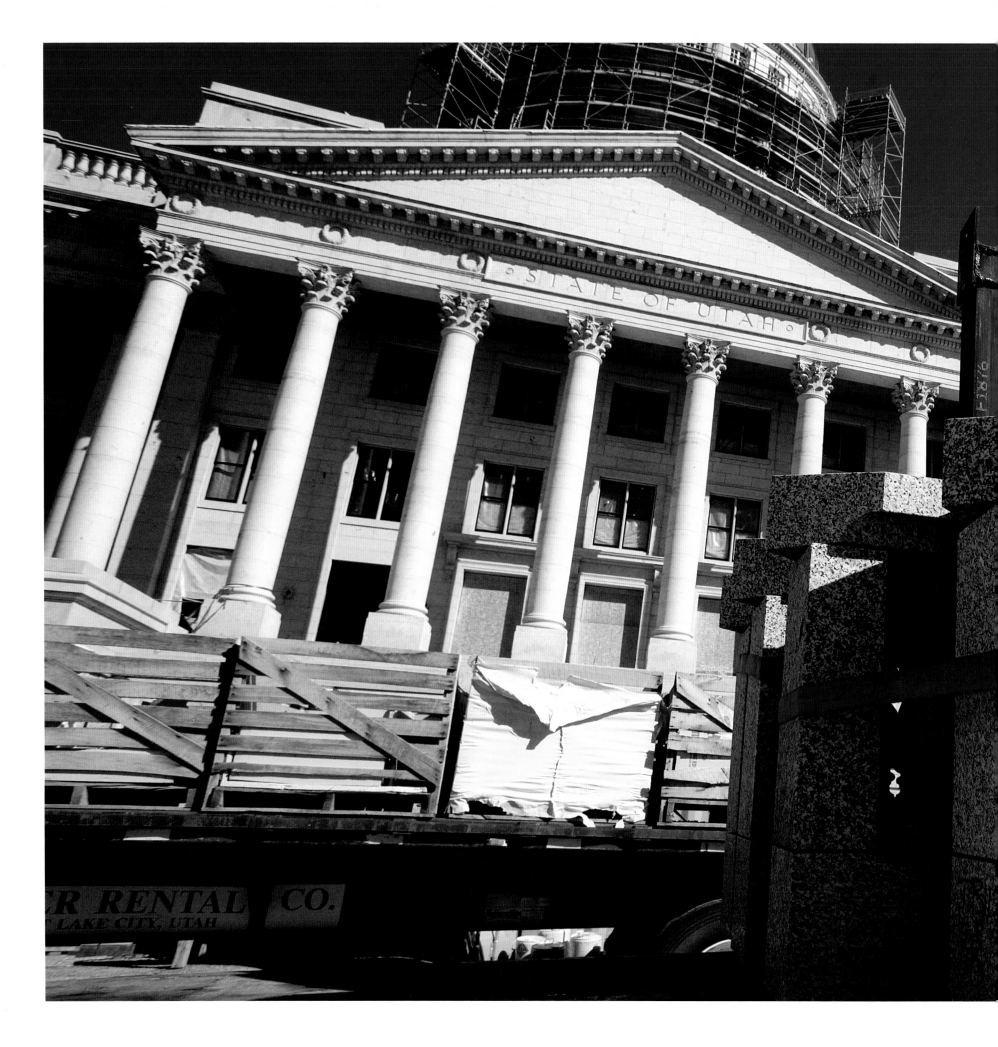

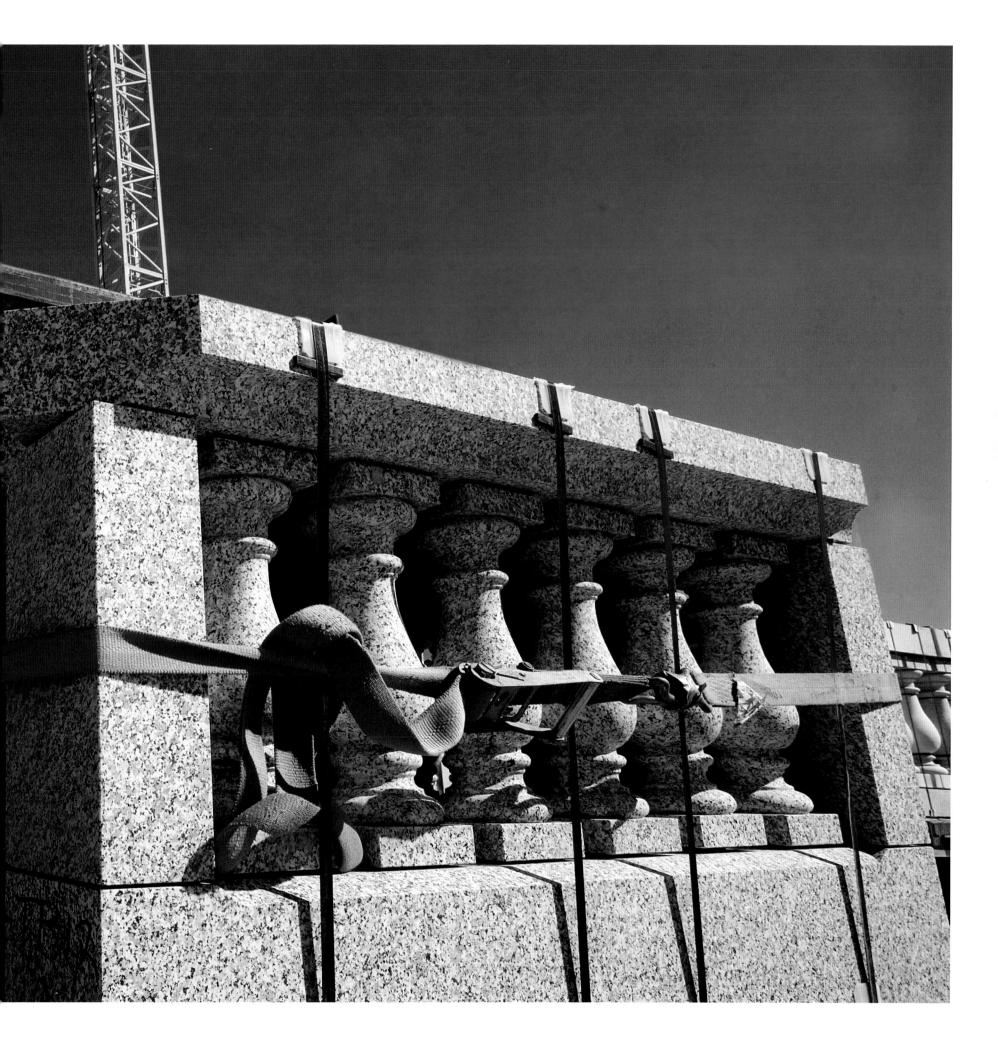

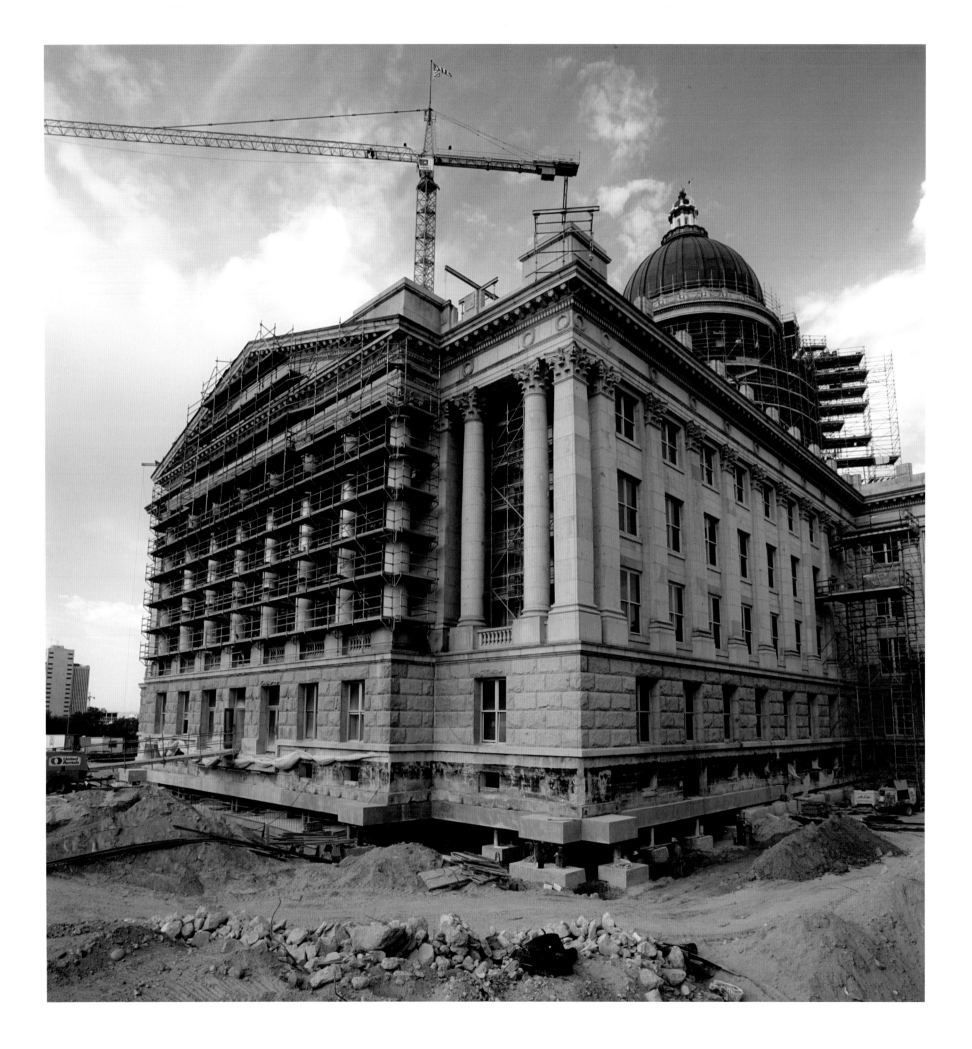

**LEFT** Base isolation of the Capitol progresses in 2005 while other restoration efforts are in full swing. Scaffolding on the north of the building facilitates terra cotta replacement on the upper drum and cleaning of the granite columns, architrave and pediment on east face continues.

# Architectural Preservation and Innovation

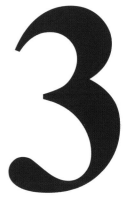

## Ninety Years of Service

For nearly a century the Utah State Capitol was home to the three branches of Utah's government. It graciously welcomed lawmakers, judges, governors, citizens, tourists, presidents, kings, mourners, elementary school students and educators, promgoers, choirs, brides and grooms, lobbyists and protesters to its comely rotunda, to the first floor exhibits, and to its offices and chambers.

In the years between the dedication of the building in 1916 and the just-completed restoration project, the keepers of the magnificent building shepherded it through regular maintenance requirements as well as the occasional disaster. As each new technological advancement was brought to the complex, the facilities management staff, together with engineers and consulting architects, sought ways to adjust the building and the grounds to the new situation while preserving the character of the complex.

Most of the alterations were carried out in response to the quite natural processes of aging, growth, and technical innovation, but many were attempts to finish Kletting's original plan.

For 20 years after the 1916 dedication of the building the four triangular pendentives at the top of the rotunda piers as well as the drum frieze—meant to be decorated with painting or sculpture programs—had remained unfinished. In 1935, with funding from the federal Works Progress Administration (WPA), Utah artists created murals memorializing the history of 18th- and 19th-century immigration and settlement in Utah. Those murals were cleaned and restored twice, in 1969 and 1996. The interior dome mural was repainted once.

Four concrete guardian lions had been sculpted by Gavin Jack in 1915 for the east and west ground floor entrances. Over the years they had suffered severe weather damage from Utah's freeze/thaw cycle. In 1977 Ralphael Plescia made repairs to renew the great beasts.

In the 1960s, new windows and doors were installed. Interior decorations, including wall paint, floor coverings, and furniture, were periodically changed in response to normal wear-and-tear as well as to contemporary styles and tastes. Air conditioning came first to the building in the form of window units, then later as a whole-building evaporative cooling system.

The effects of technology hit the Capitol in the 1960s. The Building Board's architects and engineers responded by installing dropped ceilings in several areas and by running additional power and computer cables to the House and Senate Chambers.

The Building Board, created to care for the Capitol and other state properties, occasionally had to respond to small and large disasters. In 1980 a severe windstorm ripped off parts of the dome. A new copper roof was installed.

As the new millennium drew closer, Kletting's Capitol increasingly showed worrying signs of more significant structural failure. Governor Michael O. Leavitt and the Legislature came to an enlightened consensus that they must acknowledge the urgent need to plan and financially support a comprehensive restoration project or the entire structure and its contents could be lost to future generations. The legislation creating the Capitol Preservation Board was written, passed and signed into law in 1998. And in 1999, as if nature wished to further make the point about the urgency of the Board's challenge, a rare tornado cut a swath of destruction through downtown Salt Lake City, severely damaging the Capitol grounds and parts of the building. The winds of change—at least as far as the Capitol was concerned—had definitely begun to blow.

## The Process of Architectural Restoration

Richard Kletting and other architects designing in the neoclassical style would strenuously have argued that two- and three-dimensional art and ornament were absolutely inseparable from their architectural supports. Therefore, there should be some caution regarding dividing the subject of the building's paintings and sculptures from the structural and architectural innovations and renovations. There are practical reasons for approaching the restoration of the building's architecture in this chapter and the art in Chapter Four. Thus, with all due respect to Kletting, the art and architectural parts of the project have been judiciously separated from one another. The authoritative voice of the Architect of the Capitol brings technical and aesthetic insights to this chapter on the architectural preservation, conservation and restoration of the Capitol Hill Complex. But to do so, the next section begins at a reconstruction site some 6,000 miles and 3,000 years away from Salt Lake City.

## Sir Arthur Evans' Four-Part Plan

In 1900, at nearly the same time Utah was grappling with a plan for building a new state capitol in Salt Lake City, Englishman Arthur John Evans made a remarkable 20-acre purchase on the island of Crete in the Mediterranean Sea. Sir Arthur Evans (knighted in 1911) was the "keeper" or curator of the Ashmolean Museum at Oxford for more than a quarter century. But Evans' name remains more connected with the excavations on Crete, to which he devoted a good part of his life and private fortune. Evans called the Bronze-age buildings on the island the Palace of Knossos.

Sir Arthur Evans stands at the beginning of a line of remarkable 20th century archeologists romanticized by the likes of Steven Spielberg and his intrepid Indiana Jones. It was an age when a good number of ancient objects discovered at various digs were taken from their original sites, by hook or by crook, rather than maintained and restored. Evans' contributions are sometimes criticized because when viewed from today's perspective, he often failed to adequately protect the integrity and the context of the objects he found. However, Evans' contributions to the understanding of the ancient Mediterranean world cannot be overestimated.

The study of Knossos is important to the Utah State Capitol and its restoration, because with every discovery at the ancient palace site, Evans basically had four alternatives concerning what to do with the objects or the structure.

After studying and cataloguing an object, Evans could move it in part or entirely. In some cases during this period it was not uncommon to crate an entire building for removal to a distant site. If the object was beyond reasonable repair, he could discard it, but only after it was duly noted in the record. If it could be repaired, Evans could rebuild the element with compatible materials.

---

**1** David Hart leads a detailed discussion in one of the 17 planning workshops held before design and construction commenced.

**2** A 140-feet tall tower of scaffolding fills the rotunda, allowing cleaning, art restoration, and repainting of the drum mural.

**3** A workman demolishes a floor slab prior to pouring concrete on the Third Floor.

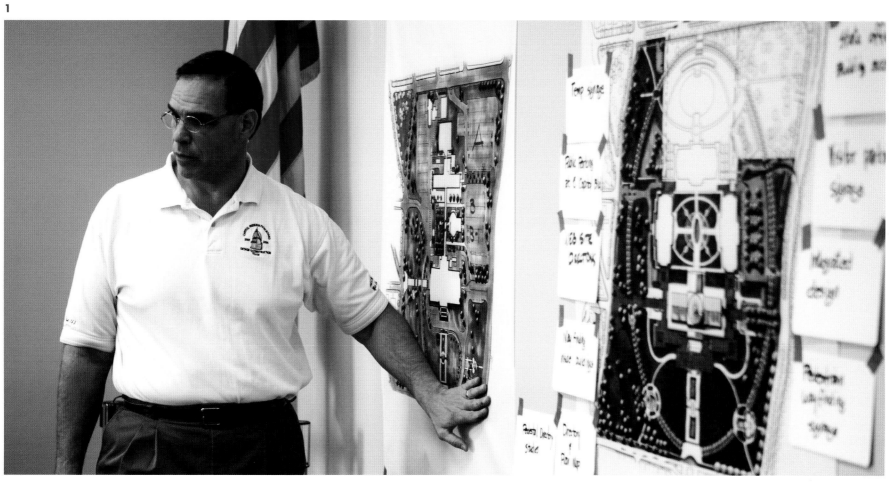

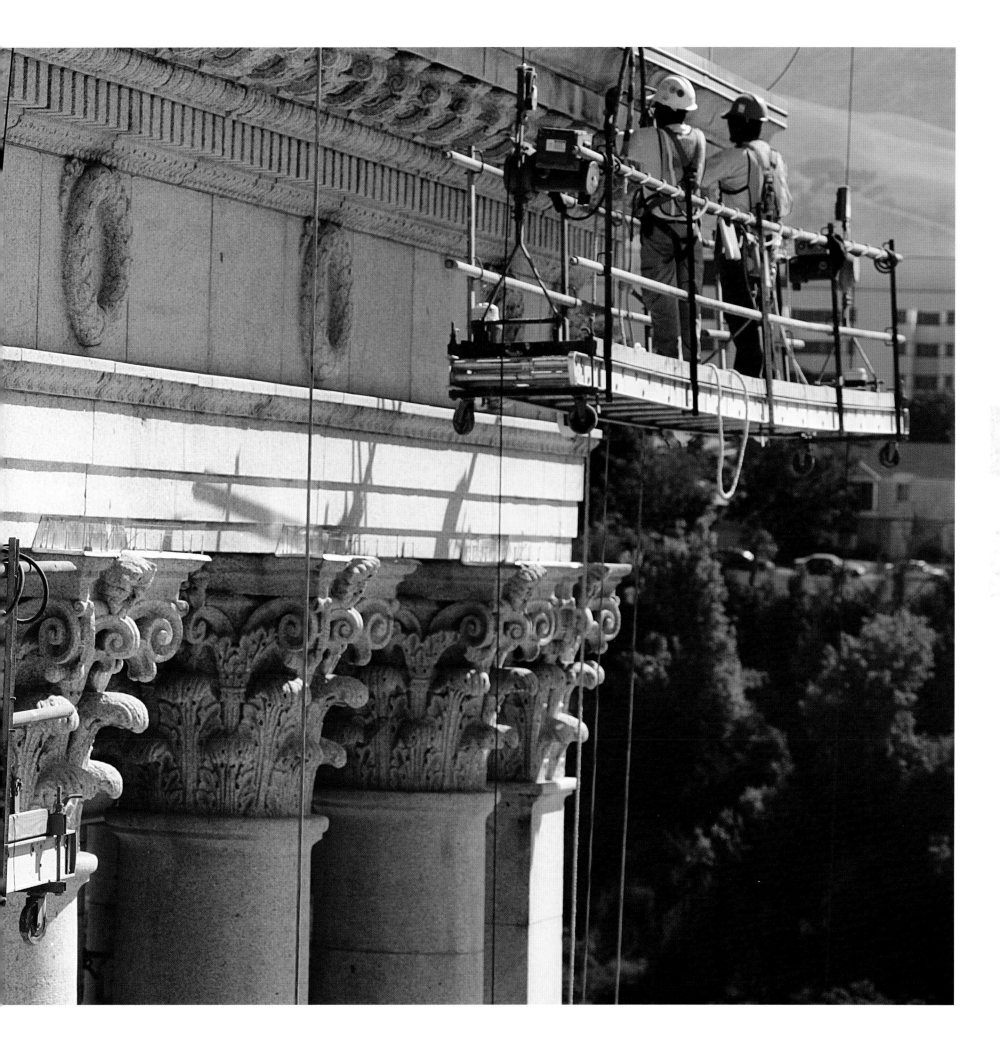

Or (and here is what is particularly important to the Capitol), Evans could preserve the element or object on site, using the least intrusive reversible procedures.

Evans, in fact, opted for all four alternatives at one time or another. Much to his credit, most of the artifacts were left on the island at the dig—a distinct departure from many other 18th- and 19th-century amateur or professional archeologists who failed in their stewardship of the sites and brought home trophies by the ton.

It is precisely because of Sir Arthur's procedural attempts at "preserving" the objects and architecture at Knossos by repair, addition, or conservation that the ancient site is relevant to the Utah State Capitol.

## The Planning Process

Evans' four-part approach to the preservation of historic sites highlights significant procedural challenges or opportunities facing the Utah State Capitol Preservation Board. Like Evans at Knossos, Capitol architects and engineers researched every aspect of the building and determined that many of its most beautiful features desperately needed to be protected from further deterioration and restored to keep the building and its occupants safe, as well as to reveal the building's former beauty. For example, the terra cotta on the great drum and dome exterior and the beautiful light fixtures throughout the building were failing. They met neither modern safety nor technical standards.

At times, planners came to understand that preservation meant first discarding worn out or failing materials. That was certainly the case with the reinforced concrete foundation of the structure. Preparation for and installation of the base isolation and earthquake protection systems in the basement and on the drum and dome were an extraordinary effort in the preservation of the historic site.

Finally, the guidelines and imperatives developed for the Master Plan required that the restoration architects stay true to Kletting's and Olmsted's intentions while at the same time improving the building's "functional usefulness." In many cases those

two imperatives could have seemed to be mutually exclusive or at least paradoxical. This is where a relatively new method of architectural design and planning called "Design Assist Contracting" came in.

Through the creative collaboration process of 17 workshops, specialists entered the project early on to provide the very best problem-solving and strategic planning possible. In some cases total rebuilds were needed to satisfy structural, mechanical and electrical demands. Strategies and tactics were designed accordingly. In other cases the team determined to make faithful reproductions of ornamental decorations or furniture. Plans, drawings, budgets and timelines were developed to accomplish those strategies.

Problems were identified and then broken down into their most fundamental components. The solutions, in the general form of guidelines and imperatives as well as specific work plans, were written for the project while looking at the building for what it was and what it could be.

## The Impact of Seismic Protection Systems

One of the primary (and Herculean) tasks was to protect the building from future earthquake activity. This was accomplished with what is known as a base isolation system. However, the installation of the system beneath the 320,000 square-foot Capitol was a huge imposition not only on the foundation but on every component of the building. This imposition was felt in several ways.

First, adding the base isolators to every supporting column in the building meant the removal of tons of soil beneath the existing foundation. In addition, landscaping, including nearly 70 mature trees (some planted as early as 1916) had to be cut down or moved whenever possible to get under the massive structure. The rusticated exterior stone shipped from the quarry in Little Cottonwood Canyon nearly a century ago had to be completely removed, catalogued and stored for later reinstallation over the seismic "moat."

The second imposition was the effect base isolation had on the structural frame of the Capitol. Old and failing support components had to be removed and new shear walls of solid reinforced concrete had to be engineered and inserted between support columns and on the exterior perimeter. These structures were asked to do double

---

**1**  One of the 265 base isolators installed beneath the Capitol allows the building to move two feet in any direction during an earthquake.

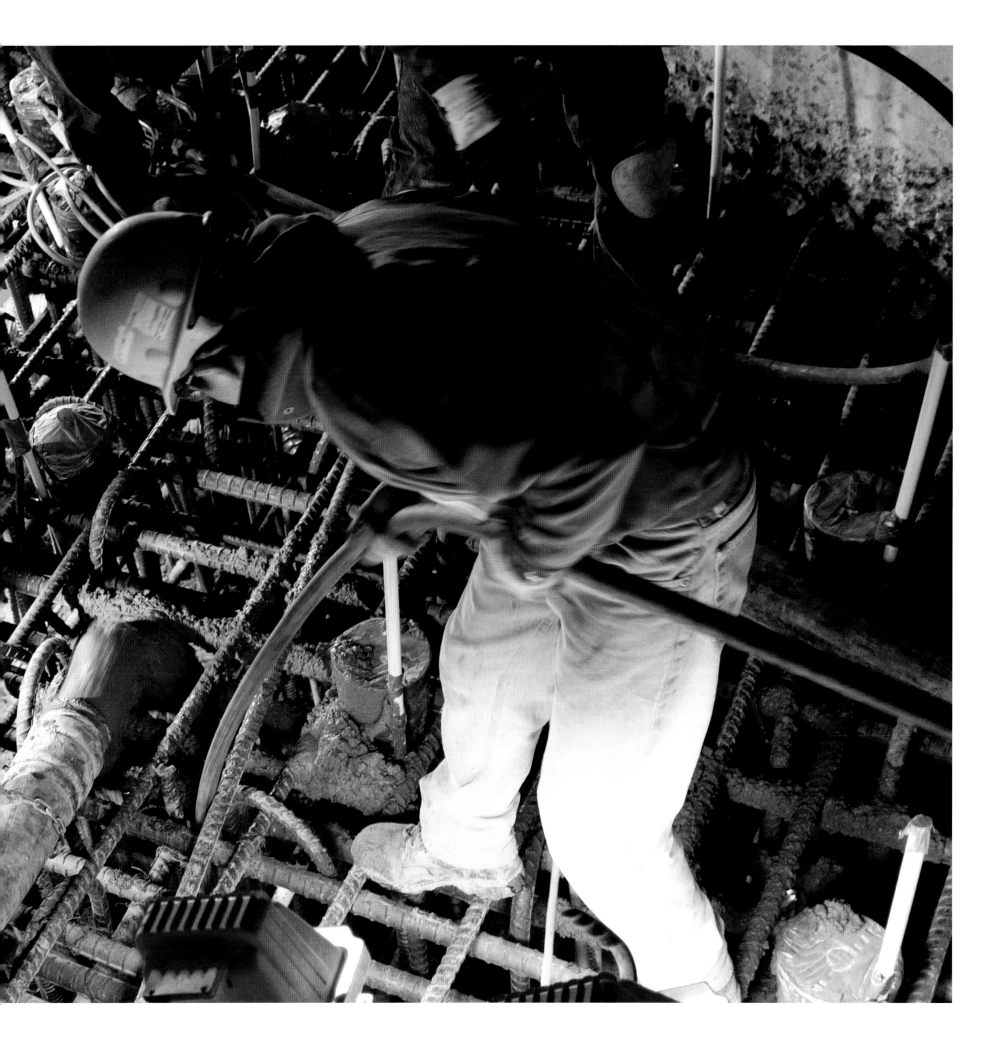

duty as walls but also as reinforcement and attachment walls for the heretofore unreinforced granite walls of the building. The new shear concrete walls had to be seamless from the bottom to the top of the structure. This meant builders had to cut and remove entire walls, finishes and ornaments throughout the interior. Only the State Reception Room (the "Gold Room") was spared the cruel impact and devastation of these structural modifications.

The entire process created so much dust and debris that safety and environmental experts devised protection and monitoring procedures for not only the building but also workers entering it each day.

When the seismic work began on the Capitol engineers estimated its weight at 132 million pounds. After the addition of shear walls and reinforcements, even after the removal of old materials and systems, the building increased by 27 percent to 168 million pounds.

## The Terra Cotta in the Drum and Dome

Translated into layman's terms, the physics of an earthquake dictate that the Capitol dome would suffer the most devastation from forces that would move component parts of the building from side to side. In turn, the horizontal shaking would produce vertical forces moving either down into the ground or up through the drum and dome of the building. The effect would be something akin to Popeye, with his amazingly muscular biceps, squeezing his can of spinach only to have its contents squirt upward with enough force to take the tin lid off the can. In the case of the Capitol, the so-called lid (what experts identify as the "diaphragm"), the circular drum and the dome would be irreparably damaged, even obliterated by any sizeable shaking and squeezing of the building's supports below.

Through the innovative Design Assist Contracting process, engineers and builders collaborated with architects and designers to create and execute a strategy that not only addressed the impact of a seismic event on the drum and dome structure, but also provided for its restoration.

For years the dome had leaked, copiously at times. In addition, Kletting had been forced to use some stucco on parts of the dome rather than other, sturdier materials.

Much of the terra cotta was failing. Plaster on the interior mural was falling. The design team created a number of imperatives addressing the dome's critical condition.

The solution attempted something just short of tearing down the entire dome and drum. All 24 exterior concrete columns surrounding the drum were removed. That required removing beams, cornices, balustrades and walking surfaces. It meant demolition of all plaster walls and removal of asbestos coatings. All terra cotta decorative elements on the dome and drum were removed, evaluated, recreated and reinstalled.

A search for one of the few remaining architectural terra cotta manufacturers was mounted. Designs were replicated and new components were poured, glazed, fired and delivered. Shrinkage and color matches consistently bedeviled the process.

At the construction site, the inner wall of the drum was given an eight-inch covering of steel bars and concrete. Lag bolts were secured through the wall and into the new concrete, holding the old drum wall in place. Layers of water-proofing materials were added to the exterior much like a new skin covering the concrete.

Behind the shroud of scaffolding covering the drum of the Capitol, in rain or shine, demolition of the existing concrete columns got underway. Waiting trucks would accept the pieces flown down by the cranes.

When all was in readiness, the new terra cotta columns, window hoods, window sills, pilasters and wall panels were assembled and installed in a systematic manner.

---

**1** Bundles of post-tensioning cables are part of an innovative system employing bridge technology developed by the engineering team for the girder system underneath the rotunda piers.

**2** Extraneous portions of the rotunda pier are demolished prior to the installation of the new beam and girder system.

**3** Metal studs are cut for framing prior to drywall and plaster work.

**4** Steel beams temporarily support structural elements such as the suspended column (which has been cut off) as the massive base isolation system is installed.

**1**

**2**

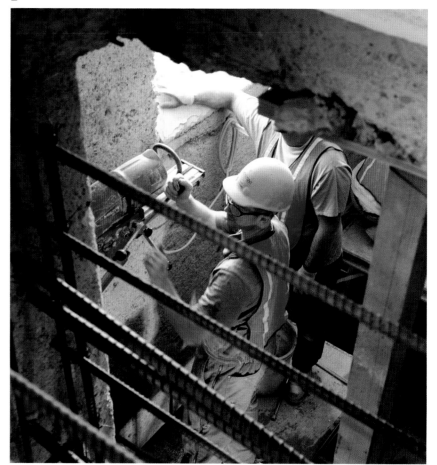

**3**

**4**

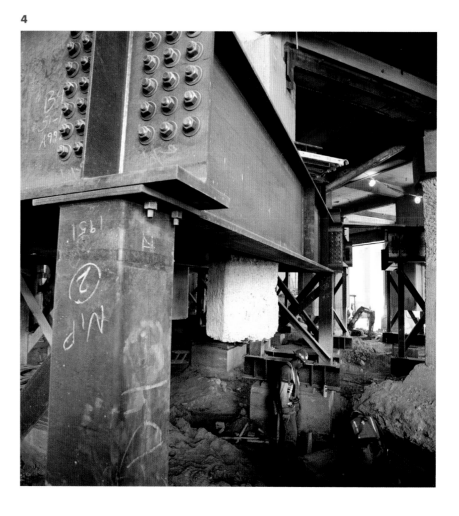

Anyone looking up at Kletting's marvelous dome will only see its beauty and will likely be unaware of the tremendous feat of collaborative restoration, preservation and conservation accomplished by the Capitol preservation team.

## Lighting and Interior Decorative Elements

At the turn of the 20th-century, architects were beginning to come to grips with new lighting systems. Rather than traditional gas flame fixtures, new construction featured the innovation of AC electric currents and electric bulbs. For the most part, electric fixtures were purchased through catalogs and then modified to fit the needs of the space. Although designs for lighting have changed dramatically over the last century, the biggest difference between today's lighting alternatives and those of Kletting's day is, however, not necessarily the designs or even methods for obtaining the electric current. The biggest change in lighting design is the materials used in their manufacture. In earlier days the fixtures were fashioned in bronze. Craftsmen would make multiple casts from various molds and then assemble parts to suit each customer. Shades and bulb covers were made of hand-blown glass or thin, translucent alabaster stone.

The light fixtures in the Capitol are no different. Every one, including the extraordinary chandelier in the rotunda space, was ordered from a catalog, shipped to the Salt Lake site and custom-wired for the particular room or space.

For the most part the period light fixtures of the building were in only fair condition. All needed new wiring. Many had damaged bronze components and shades. Some were missing shades altogether. Architect Rob Pett contacted lighting manufacturer Rambusch Studios of New Jersey to assess the collection. Edwin Rambusch is part of a fourth generation of a 100-year-old company that specializes in restoration of historic buildings. The Rambusch team made detailed full-scale drawings of each piece. Each fixture was assessed in much the same way archaeologists at the Palace of Knossos would have approached their discoveries. Many fixtures were crated and sent to New Jersey for restoration. Others were cleaned and consigned to a storage warehouse in West Valley City to await reinstallation. Some with missing parts were put aside until and if replacements could be found.

The restoration team found quality replacements for missing shades from a number of sources. The team also commissioned quality reproductions. One seemingly insurmountable challenge remained: the rotunda chandelier. The glass shades that produced "wonderfully soft white light" could not be duplicated. They were manufactured from ingredients including lead that were now deemed hazardous contaminators of the environment.

The nearly miraculous solution to the rotunda predicament came through a chance acquaintance. Wilson Martin, Utah's historic preservation officer and Capitol Preservation Board member, had a counterpart and friend in Arkansas. The state Capitol in Little Rock was undergoing a similar restoration. The Arkansas Capitol had an identical chandelier manufactured by the same St. Louis lighting company. As the two men talked, Utah's dilemma became apparent. And the result was that Arkansas' Secretary of State Charlie Daniels made an official gift of his state's identical shades to be used in the restoration of Utah's rotunda chandelier. The magnanimous gift "was the best thing for history," wrote Secretary Daniels, "in that one chandelier of this vintage could be complete, a much better alternative than each state having its own incomplete one."

Numerous other decorative elements throughout the Capitol, including the restored faux graining on metal doors which Kletting specified for fire protection, will be readily appreciated by those who enter the building. Other features include gold-leafed and stenciled crown trim around walls, and the faux painting on the atrium walls that gives the appearance of huge stone blocks. The list is a magnificent testament to the planners and the process of intelligent, painstaking restoration of a state treasure.

---

**1** A stone mason installs the first piece of granite on the new southwest terrace. Granite for the restoration, quarried in Sardinia, Italy, provided a close match to the color and pattern of the original Little Cottonwood Quarry granite, which was no longer available.

**1** New terra cotta for the drum wall, pilasters and cornice was designed to replicate Kletting's specifications. Wood windows, patterned after the originals, were designed to meet current energy codes.

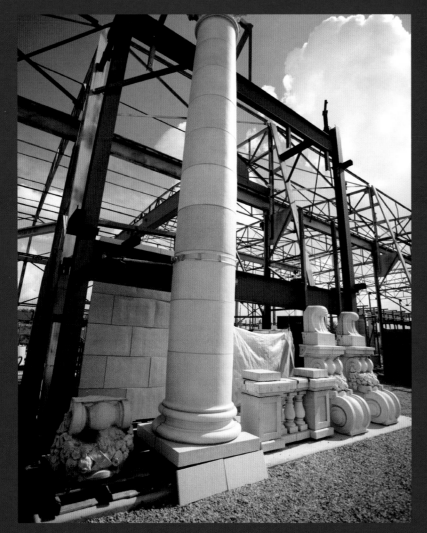

New terra cotta columns are assembled in the KEPCO yard in Salt Lake City. These are the largest known column drums fabricated in North America.

# Terra cotta

Terra cotta (sometimes spelled terracotta or terra-cotta) literally means, in Latin, *cooked earth*. Terra cotta most often refers to the color of the pots for gardens or kitchen crockery made of the distinctive red, kiln-fired clay.

Discoveries of terra cotta objects date back to ancient Greece. Perhaps the most famous small-scale terra cotta artistry comes from the della Robbia family in Italy. The family's intricate sculptural works were so often used in architectural decoration during the Renaissance that any very fine work in terra cotta became known as della Robbiaware.

At the turn of the 20th century terra cotta architectural forms were used in an enormous number of modern buildings. The reasons for its popularity are fairly simple.

First, if properly glazed and fired, the form is a durable and strong, water- and heat-resistant building material and is indistinguishable from stone to all but the most trained eye. Second, before firing, clay can be literally sculpted into nearly any shape. Unlike unforgiving marble, an artisan can make a mistake on a clay model and merely need to add a fistful of clay back to the work! Nothing in stone is quite so easy. Third, high-quality architectural terra cotta is generally not a solid mass but rather has a hollow back so the weight of a piece is considerably less than stone. Finally, even the finest quality glazed architectural terra cotta is much less expensive than stone—a boon for budgets in large projects.

Many visitors to the Capitol would be surprised to learn that the drum (with balustrades, columns and other ornamental elements of the classical architectural design) that supports the mighty copper-roofed dome of the Utah State Capitol, in addition to the cupola or lantern at the very top of the dome, is entirely made of terra cotta.

During the initial studies of the building's physical condition, experts, including Board member Ray Short, found that the terra cotta had, by virtue of temperature variations and water melts and freezes, deteriorated to an alarming extent. Tests indicated that new terra cotta needed to replace the near century-old elements. But very few companies in the United States still make architectural terra cotta of sufficient quality for the Utah Capitol.

As the building opens to visitors and the work of government in Utah, the new terra cotta has come to the project from Boston Valley Terra Cotta workshops in Orchard Park, New York, a company producing extraordinary, high-quality, made-to-order works since 1889.

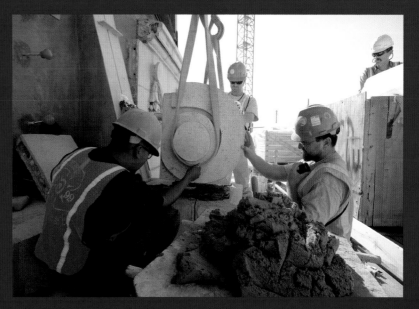

Stone masons install the first scroll at the base of the console assembly. Old terra cotta was removed and restored, and new terra cotta elements were replicated as needed.

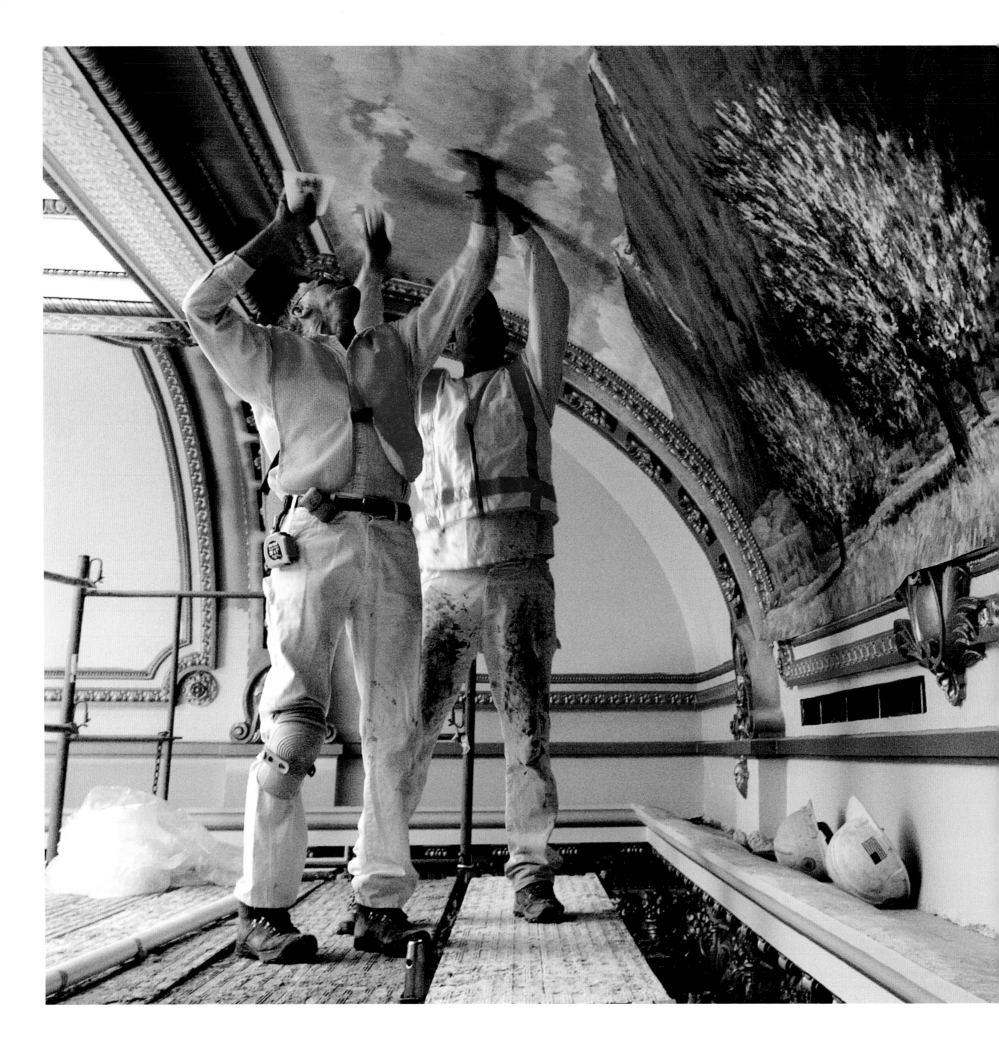

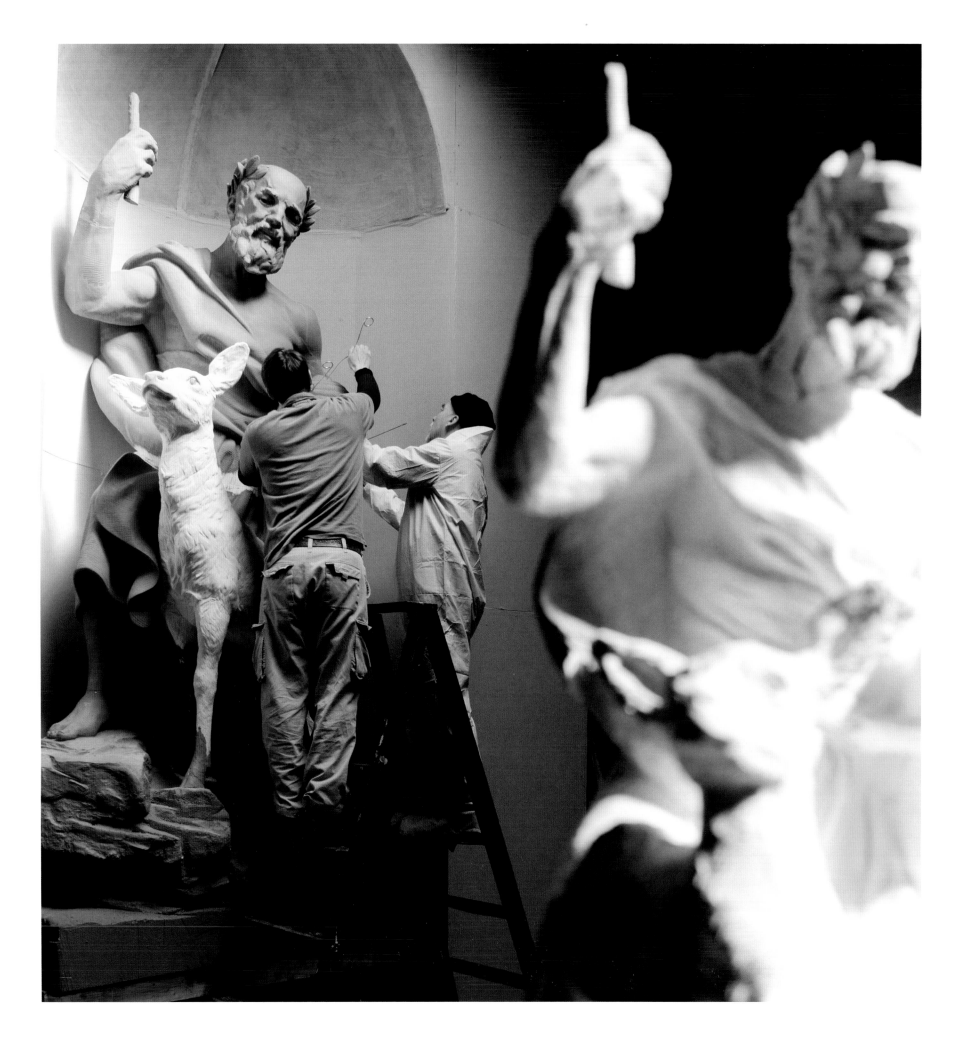

**LEFT** Jonah Hendrickson and Eugene Daub work on a full-scale model of *Land and Community.*

# The Capitol Art Collection 4

## Capitol Commission's Original Inventory

Doctor Philip Notarianni, director of Utah's Division of State History, attributes Utah's economic coming of age to two essential developments of the late 19th century, events parallel to those on the national scene that created the patrons of the Temples to Art and Democracy. The first is the expansion of transcontinental railroad lines through Utah. The second is the development of the enormously lucrative mining industry in the Territory, with its supporting secondary and tertiary businesses. Notarianni notes that hoped-for statehood owed a great deal to "the development of mills and smelters needed to make shipping of ores and concentrates a profitable enterprise" by rail. The creation of the Salt Lake Stock and Mining Exchange and other supporting businesses made Salt Lake City a "regional center for foodstuffs as well as mining implements and machinery."

The wealth of several mining and railroad individuals who became patrons of the arts was a significant source of the state Capitol Collection which is now restored and on permanent exhibition in the Capitol.

In 1899, State Rep. Alice Merrill Horne had created the Art Institute and the means to begin what is today known as the Alice Collection. A decade later the Capitol Commission was appointed; the Commission's call for building plans included a request for space for the Institute, as well as language we can fairly interpret to mean a budget for art. Section Eight of the Commission report, Cost of the Building, indicates that the expense of the construction must include "decorations and . . . everything, in fact, necessary to the completion of the building ready for occupancy; furniture only excepted." Hence, in addition to the required important Fourth Floor gallery and meeting spaces for the Art Institute, Richard Kletting specified, as per the demands of the Competition Program, murals for the House, Senate, and Supreme Court Chambers, the State Reception Room and both ends of atrium vaults extending from the rotunda. The Philip Dern Decorating Company, a local interior decoration firm, wrote the winning bid to include the proposed murals as part of the contract.

Kletting's winning front elevation rendering shows a sculptural program for the pediments and roof. Interior plans also specified high reliefs for the rotunda frieze. The plans also called for monumental niches in each of the rotunda piers, obviously to hold equally monumental sculptures.

We know now, from the Commission's final report that not all the art, or what the competition documents called "decoration," was realized. The state simply had no more money to spend on decoration for the building. However, this is where the wealthy few who had profited so handsomely from the flourishing mining community entered the scene.

The 1916 final Commission report lists the art specifically given to the state for purposes of exhibition in the building itself. Mining millionaire Colonel Edwin Holmes gave a total of five paintings by his personal friend, nationally renowned H.L.A. ("Harry") Culmer. Works of *Caroline Bridge*, *Augusta Bridge*, *Southern Utah's Monument Valley*, and the *Kennecott Copper Mines* (the source of much of the state's wealth), were given for "permanent display" in the building.

Hand-written letters from the new state's most famous artists, dated to correspond to the final report, discuss the sculptural program at length. However, since the money was gone, spaces set aside for monumental bronzes and noble marble friezes were left empty or were filled with temporary works.

During the Great Depression, murals for the rotunda pendentives and the dome frieze were added through the work of Utah WPA artists under the direction of Lee Greene Richards.

## The Capitol Collection

Visitors to the gloriously restored Capitol will see several new and spectacular additions to nearly 70 familiar works—the murals, governors' portraits, and sculptures officially listed as permanent loans to the Collection from the Utah Arts Council's Alice Collection. Many of the free-standing works of art are now installed in restored spaces that enhance conservation and cleaning. New period frames have been constructed for some of the paintings. Appropriate mounts and newly written labels that tell the story of each painting and artist are part of the public art program in the restored Capitol.

In addition to seeing conserved old friends, visitors and patrons can expect to see 91 additional works, newly acquired by a specially created committee assigned to find works by the best historic Utah artists or works about Utah to complete Kletting's plan and serve the purposes once specified by the people, the Commission and Alice

Merrill Horne. The pages that follow offer an exhibition in printed form, together with details and commentary on the artists, the media and the subjects of the extraordinary Capitol Collection.

### Portrait of Capitol Commission

In recognition of the monumental effort of the first Capitol Commission, the 1915 Utah Legislature directed John Willard Clawson to "paint a portraiture of the members . . . for the sum of $7,500." Clawson, a native son of considerable international reputation, was nearing 60 years old. He had studied at the École des Beaux-Arts in Paris; in 1903 he had been elected to the avant garde Societe du Salon d'Automne. Clawson's painting shows the commissioners at nearly life-size scale. Organized in 1907 by Governor William Spry, the Capitol Commission directed the design and construction of Kletting's Capitol through nearly a decade of debate, selection and, at times, controversy.

## Hall of Governors

The close of each Utah governor's administration has been marked by commissioning a portrait of the governor by an artist of his or her choosing. At one point in the building's history, those portraits were hung on the polished marble walls of the great vault flanking the rotunda space. Today, visitors can see the portraits and learn about the state's distinguished leaders in the newly restored First Floor Hall of Governors.

---

1   *View of Bear Lake,* a study in oil on canvas by Lee Greene Richards, is one of the new purchases for the Capitol Collection. Richards also painted the murals in the rotunda and the scene of Utah Lake in the Senate Chamber. *Baczek Photography*

2   Paintings conservators from WCCFA documented every step of their procedures. A detail of John Clawson's restored portrait of Heber Wells, Utah's first governor, reveals soft background hues.

3   Logan, Utah muralist Keith Bond stands before his newly installed Senate Chamber painting, *Orchards along the Foothills of the Wasatch Mountains.*

4   *Centerville,* by revered Utah artist LeConte Stewart, is one of 11 paintings added by the Senate to its collection. *Baczek Photography*

**1**

**2**

**3**

**4**

**1** Nationally recognized sculptor Eugene Daub works to refine a full-scale model
for one of the four niche sculptures.

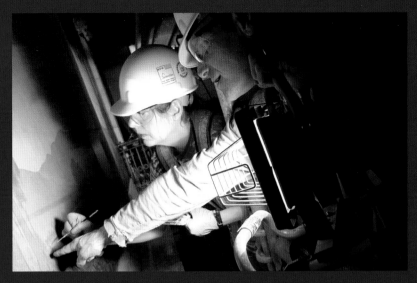

Conservators Camilla Van Vooren (left) and Carmen Bria restore artwork in the atrium lunettes.

# Conservation and Commissions
**for the Capitol Collection**

The two-dimensional artwork in the Capitol—murals and framed paintings—presented a number of challenges for the restoration team. Existing works of art needed attention in the form of cleaning, repairing, reframing and labeling. Their placement inside the building required reconsideration. Many of the works were once hung in such a way as to damage the exquisite marble veneer paneling. Empty spaces, originally shown as the locations for additional murals or framed pictures, wanted filling. Because leaving a complete record for future visitors, historians, educators and students is a high priority, everything needed appraisals, cataloging, registration and written histories for entry into the new digital collections management software.

In 2004 the Board asked the Western Center for the Conservation of Fine Art (WCCFA) to evaluate the condition of the murals and framed paintings. WCCFA was particularly well-suited to the task. Chief conservator Carmen Bria, who was a founding member in 1984 of the firm, brought an impressive background and education to the task. With a bachelor's degree in chemistry and a Master of Science degree in paintings conservation, he held to the concept that works of art should be treated with the most advanced, non-invasive yet stabilizing methods known in the profession. Modern conservation specialists like Bria and the other conservators at WCCFA—Camilla J. VanVooren, D. Hays Shoop and Leonard Evans—work in a highly specialized discipline that requires standards of competency worth noting for the record. Every conservator at WCCFA has trained in places such as the J. Paul Getty Museum, the French Atelier de Charles Francois Daubigny, the Courtauld Institute of Art in London, and the Winterthur at the University of Delaware,

thus adding luster to solid credentials in the science required to bring the Capitol's collection to its best and most stable condition.

Bria added the firm of Dry Creek Gold Leaf to the group to restore aging or damaged frames or, in some cases, to create accurate replacement frames based on research of original collections.

In 2004, literally as the building closed, paintings were fitted into custom-built crates for shipment to the WCCFA studios. Every portrait of every governor, together with the paintings from early donors to the collection, eventually made their way to the studios. Each painting enjoyed a thorough "going over." Treatments were proposed. Photo and written documentation of the conservation process was painstakingly assembled because future generations would need the equivalent of a medical history on the works. Meanwhile, at the Capitol Preservation Board offices, two responsibilities lay ahead: First, accurate research on the artist, the subject and the context for each painting needed to be compiled and prepared for publication. Second, Bria and the other conservators would climb 17 stories of scaffolding to clean, repair and restore the fixed murals throughout the Capitol over a period of nearly a year.

The last challenge for the preservation project was the commissioning and purchasing of new works of art. For the Senate and House Chambers, committees representing both legislative bodies settled on topics and themes, issued a request for qualified artists' proposals on the themes, and selected and commissioned the winning artists (David Koch for the House and Keith Bond for the Senate, both from Logan, Utah). The murals were painted in the artists' studios, carefully rolled on tubes and installed in the chambers using virtually the same procedure as hanging wallpaper in a private residence. They are an exquisite and entirely appropriate compliment to the murals painted in the early decades of the 20th century.

As a final contribution to the restored Capitol, the Art Placement Subcommittee as well as the Utah Senate authorized the purchase of more than 40 works of art by well-known Utah artists, both past and present, to grace the walls of public reception areas and ceremonial offices of elected officials throughout the building.

Now known as the Capitol Collection, the paintings, together with the sculptural works of art in the Utah State Capitol, represent the best Utah has to offer. They will be protected as such. They come to the restored Capitol—appropriately restored and conserved in their own right—from the Alice Art Collection begun by Alice Merrill Horne. They come from the works given to the Capitol Commission in its early days as well as from contemporary private donors, patrons and museums. And others come as a result of the work done by the subcommittees and artists responsible for the extraordinary newly commissioned works of art.

## Children at Play

The State of Utah's formal reception room, located next to the spacious office suite of the governor and lieutenant governor, is referred to as The Gold Room in popular speech to reflect the opulent style of the furnishings and decorative painting. The unique ceiling mural, called *Children at Play*, painted by Lewis Shettle, is reminiscent of the delicious pinks and blues of French neo-classical artists.

## Brigham Young

This monumental bronze of Utah's first territorial Governor Brigham Young was sculpted in 1996 by Utah artist Kraig Varner who chose an image of the more youthful church president, colonizer, and civic leader. United States President Millard Fillmore appointed Young as the first territorial governor in 1851. In Varner's larger-than-life portrait, Young strides confidently into history. The sculpture captures the personality of the man historians often refer to as the "American Moses."

## Caroline Bridge

The third and final Capitol Commission Report of 1916 itemized three paintings by H. L. A. Culmer donated specifically to the Utah State Capitol by mining magnate and art collector Colonel Edwin F. Holmes. Two of the paintings were recent works by "Harry" Culmer, a personal friend of Holmes, made after the two led a party to the newly created Natural Bridges National Monument in Southern Utah about 55 miles west of the town of Blanding. Culmer was stylistically and philosophically associated with the famous Hudson River School painters whose breathtaking landscapes assumed that Nature was vested with heavenly powers to renew and save mankind. The largest of the three paintings, *Caroline Bridge*, is the backdrop for the Supreme Court Chamber on the Third Floor of the Capitol.

---

1   WPA artists were commissioned to paint the rotunda frieze and pendentives in 1935. The cycle depicts 19th century pioneer life in the Salt Lake Valley. This detail is titled *Gulls Save the Wheatfields*.

2   As part of the ceiling decoration for the State Reception Room, Lewis Shettle pictured an idyllic scene of *Children at Play* in delicious pastels.

3   After severe deterioration, John Henri Moser's *Edwin Bridge*, painted in 1917, was sent to WCCFA for extensive restoration. The badly damaged hand-carved frame was repaired by Dry Creek Gold Leaf, Inc., historic restoration framers. *Baczek Photography*

## Dr. Martha Hughes Cannon

Laura Lee Stay's superb sculpture of State Senator Dr. Martha Hughes Cannon, the first woman to be elected to a state senate in the country, was completed in 1997 and stood briefly in one of the rotunda niches. The monumental bronze image of Cannon, who was elected in 1896, now appropriately welcomes visitors and senators in the lobby of the new Senate Building on the east side of the plaza. Other one-time "residents" of the rotunda niches, Emmeline B. Wells and Maurice Warshaw, and other works in the Capitol Collection are now part of the restored Fourth Floor exhibit galleries.

## The Pendentives

Architects use several methods for enclosing the concave, triangular space formed between the perpendicular abutment of arches of a building and the drum of a dome. These three-dimensional triangles, called pendentives, offer significant spaces for artwork. The Capitol's massive pendentive murals, designed by Lee Greene Richards, illustrate four of the significant 18th and 19th century European expeditions into the Great Basin, each leaving lasting contributions to Utah's rich geographic and cultural heritage: Father Escalante and other Spanish fathers who explored Utah's southern counties; famed cartographer John C. Fremont who mapped the great rivers and lakes of the territory; Brigham Young and the beginnings of Mormon immigration marking the creation of modern Utah's cities and towns; Peter Skene Ogden and other trappers and tradesmen of northern Utah.

Richards' other work in the Capitol includes portraits of three early Utah governors as well as one of the landscapes in the Senate Chamber.

## The Cyclorama

The Capitol Commission's 1915-16 final report "strongly" recommended an appropriation of $15,000 by the 1917 Legislature to fund commissions for sculpture in the new building. Until that art was installed, the Commission reported, the building would "not be properly finished." The requested appropriation was a sizable one for the time, close to $300,000 in 21st century value. The recommendation included art for exterior works in the pediments above all entrances and for the frieze or ribbon of space just below the interior dome of the building. The Legislature was unable to fund the project.

The great rotunda space was left unfinished for nearly 20 years until, in the midst of the Great Depression, the Works Progress Administration (WPA) provided jobs and wages for more than three million unemployed men around the nation, including a talented few in the Mountain West. The program funded arts projects for public facilities including the Utah State Capitol. Hence, the frieze was realized in paint rather than stone. Eight scenes (*Irrigation by Pioneers*, *Driving the Golden Spike*, *General Connor Inaugurates Mining*, *Gulls Save the Wheat Fields*, *Naming of Ensign Peak*, *Peace with the Indians*, *Pony Express and Stagecoach*, and *Social Gathering at the Old Bowery*) were designed by Lee Greene Richards and executed by at least four other WPA painters.

## Seagulls in Dome

The original and unknown artists of the dome painted a scene specified by the Philip Dern Decorating Company. The company's 1914 proposal to the Capitol Commission —the letterhead advertises specialists in "artistic wall decorations"—calls for the "ceiling of the rotunda" to be painted "to obtain clouds and sky with the suggestion of sea gulls flying" 165 feet above the floor below. The bird, they added, was "very characteristic of Utah and a very interesting effect [could] be obtained." The painted scene was completed soon after the Capitol's 1916 opening. In 1969 Alfred E. Lippold & Co. made repairs in the fresco, and as part of the 2007 restoration, the entire ceiling was repaired and conserved by artists working with Evergreene Painters.

## East and West Lunettes

The first commissioned works of art in the Capitol were finished in the great arches at the ends of the atrium vaults in 1917. The east mural is referred to as *The Madonna of the Covered Wagon*. This tribute to the early pioneers who crossed the American plains to eventually settle in Utah was officially titled *The Arrival of the Pioneers in the Great Salt Lake Valley in 1847*. The west mural is most often called *The Passing of the Wagons*; the official title was listed in the Capitol Commission Report of 1916 as *Reclaiming the Desert by Irrigation*.

The paintings are signed by Girard Hale and Gilbert White. White was born in Michigan in 1877. He studied at Columbia University and became an expatriate in Paris for more than 40 years. The younger Hale may have met White in New York, or perhaps in Paris. Although the Commission report lists Hale as a Salt Lake resident and White as a New Yorker, the lunettes and other murals were painted on canvas in White's Paris studios and shipped to the U.S. to adorn the walls of the state capitol buildings in both Utah and Kentucky.

## The Lions

Utah author Elaine Cannon wrote fondly of childhood summers spent on Capitol Hill that included eating lunch while nestled in the cement paws of one of the four great lion sculptures guarding the east and west entrances of the building. The originals, made in 1915 by Gavin Jack for $800, were repaired in 1977 by local artist Ralphael Plescia. Weather continued to deteriorate the creatures enough over the next 25 years to require commissioning entirely new sculptures as part of the restoration. Like Elaine Cannon, Capitol project designer Rob Pett sat beneath the great lions in his childhood, and felt strongly that something had to be done to restore and preserve the four lions for future generations. Rather than use the same concrete material that weathered so poorly over time, project managers determined new lions would be carved from Carrera marble. Sculptor Nick Fairplay traveled to Carrera, Italy to select four 15-ton blocks of marble. Once quarried, the blocks were shipped to Fairplay's Ohio studio. Prior to actually starting the carving, large and small scale models were made of each lion. Each lion has its own unique personality representing one of four virtues: Fortitude, Patience, Honor and Integrity. Fairplay and his four assistants spent more than eight months sculpting each new lion that will now sit as a sentry at the east and west entries to the Capitol.

---

**1**  Artisan Nick Fairplay carves one of the four new marble lions in his studio.

**2**  Logan, Utah artist David Koch proposed two new murals for the House Chamber cove ceilings. Master craftsmen Henry Carsten and Jason Christensen installed *Seraph Young Votes* and *The Engen Brothers Construct the Ecker Hill Jump* in May of 2007.

**3**  Carmen Bria of WCCFA conserves the northeast WPA pendentive mural of Jim Bridger and other early northern Utah trappers.

**4**  An artisan prepares molds prior to the bronzing of the four niche sculptures.

**1**

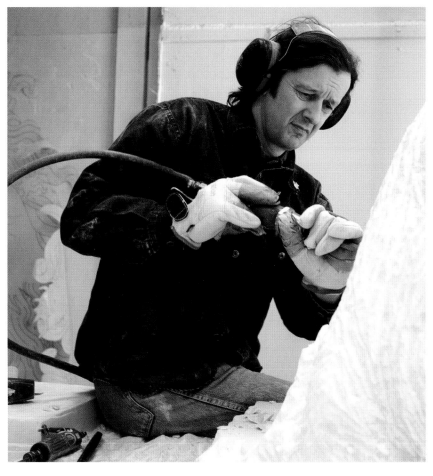

**2**

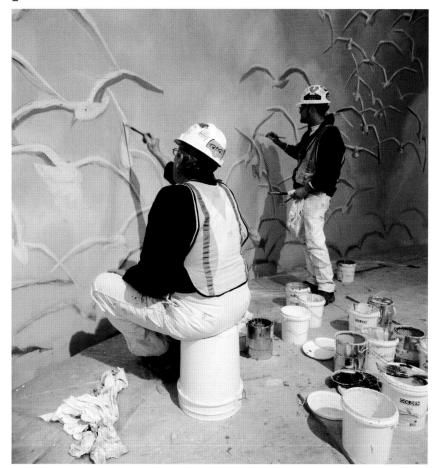

**3**

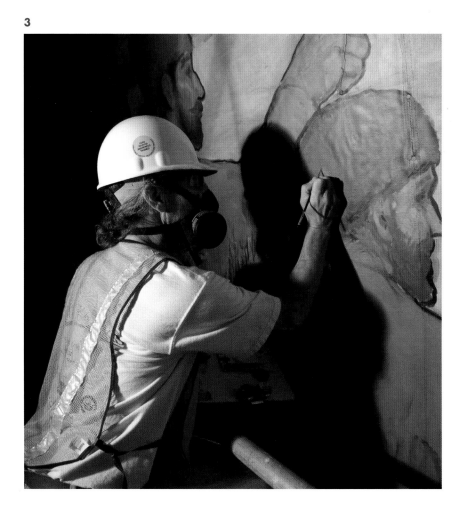

**4**

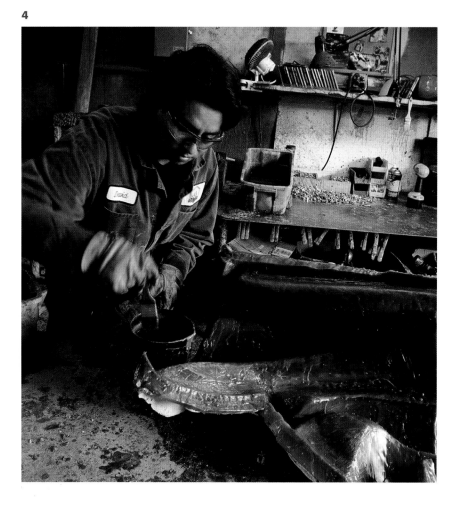

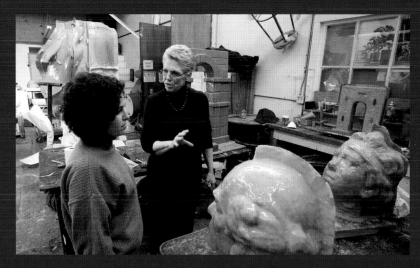

Allyson Gamble (left) and Judith McConkie review rubber molds for one of the niche sculptures, *Science and Technology*, at the Artworks Foundry.

# The Great Utah Rotunda Bronzes

Renowned American sculptors Eugene Daub, Rob Firmin and Jonah Hendrickson proposed monumental bronze sculpture groups for the Capitol's four rotunda niches. The group, known as DFH, won a nationwide competition to fill the empty niche spaces by submitting small-scale clay models called maquettes they sculpted in the Beaux Art style prescribed by Capitol Architect Richard Kletting.

Kletting wanted the 13-foot spaces in each of the rotunda piers to be filled by allegorical figures representing concepts that describe Utah's founding principles. In addition, the figures needed to address the ideal of responsibility—that every generation must somehow transmit to the next treasured parts of the past, all the while looking to the future, in order for the children of the children's children to know who they are as well as what they can become. The titles for the works are pairs of concepts, the idea being that the sum of the two words is far greater than the individual words themselves: *Arts and Education, Land and Community, Immigration and Settlement,* and *Science and Technology*. Every detail on every figure is a symbolic statement about the title themes.

As the process of sculpting and casting continued, the 11-feet-tall figures began to be referred to as "The Great Utahs" by DFH as well as the Artworks Foundry. It is easy to see why. The figures dominated the entire foundry.

The procedure for casting such large scale multi-faceted works of art in bronze is extremely difficult to describe in words; pictures help. But the impression that remains in the memory of even the occasional observer of the process is that each sculpture group is truly great and truly about Utah.

In the beginning stages of the process, the maquettes were modified to incorporate requests made by the selection committee representing the Arts Placement Subcommittee and the Capitol Preservation Board.

Once approved, the maquettes were scanned, and by the magic of digital technology, enlarged to enormous dense foam figures. The artists went to work sculpting the details and refining the gestures and draperies of the full scale models only to have them cut into dozens of manageable parts. Rubber molds were made of the various parts, each labeled as sections of a three-dimensional puzzle. The rubber molds were covered by a "mother mold" made of plaster followed by complex steps of disassembling and re-assembling the various molds until each piece was filled with wax to create hard but nonetheless maleable reproductions of the original parts. Artisans carefully refined and prepared hardened wax pieces for the next step.

The wax pieces were dipped in vats of special liquids and silica-sand to form a hard outer shell. The hard molds were then heated to high enough temperatures to melt the wax. The liquified wax drained out through "sprues" and gates and in its place molten bronze was poured into the molds.

Once cooled, the molds were removed; the pieces of the puzzle were assembled and welded together. More artisans set work "chasing" or refining edges and seams.

The final step in the process was to add color and finish to the giant figure groups by means of chemical abrasives and the deft use of a blow torch and small brushes.

Called the "patina" of the bronze, the finish was chosen to harmonize with the rotunda surroundings.

The Great Utahs were shipped from the foundry in their own specially designed cradles and installed in their permanent homes in October of 2007. They became, in effect, the colossal children of Daub, Firmin and Hendrickson who brought Kletting's dream full circle.

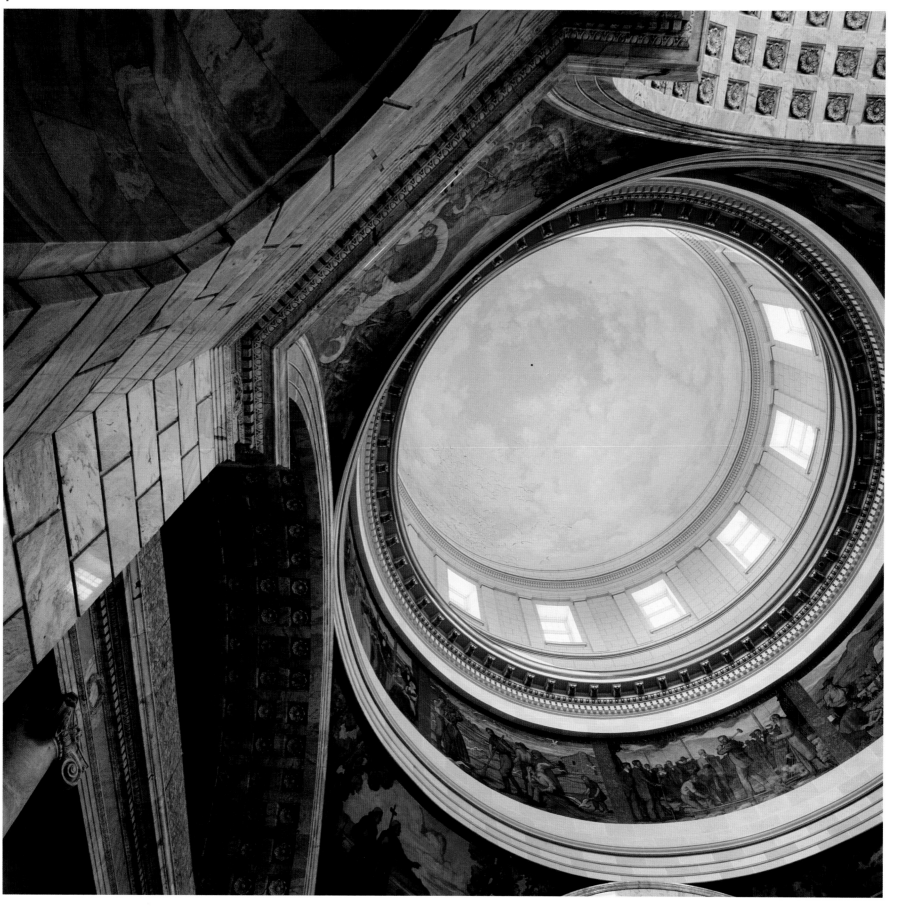

**1** Light filters through the new dome windows above the restored WPA murals on the rotunda frieze and pendentives prior to the hanging of the fully restored chandelier.

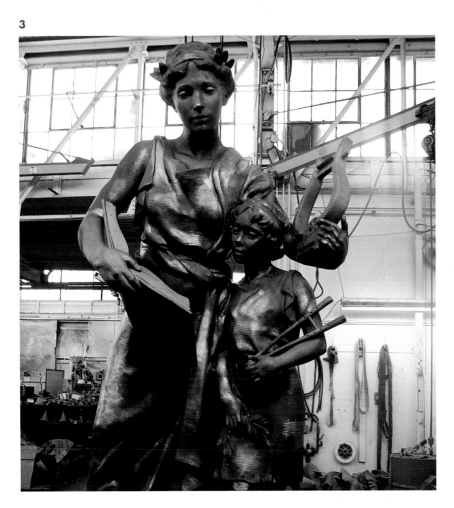

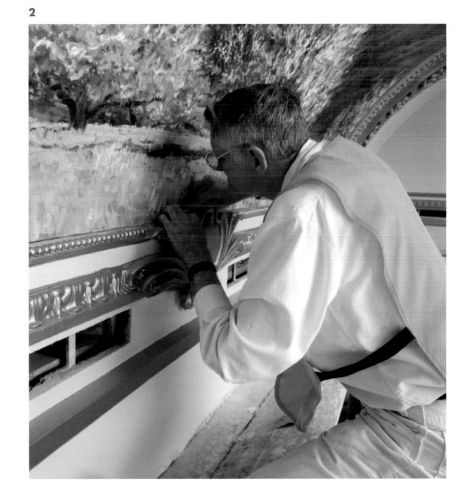

## House Chamber Murals

The 1914 contract for the interior furnishings and decoration of the Capitol was awarded to the local interior design firm Philip Dern Decorating Company. The Dern proposal specified murals for the House, Senate and Supreme Court Chambers, the Governor's Board Room, and the interior dome of the rotunda. Except for the rotunda (sky, clouds, and seagulls that were "very characteristic of Utah and a very interesting effect"), only the most general subject matter for the murals was described in the Dern proposal.

On the east and west cove ceilings of the House Chamber, Dern proposed a "painting of irrigation in three panels" and something "emblematic of the State of Utah" respectively. Paintings on the north and south coves—to be completed sometime in the future—were to be allegorical subjects addressing the themes of mining and agriculture. The muralists were to be only of "the highest class." Dern would employ Utah artists whenever possible.

The two House murals produced as part of that Dern contract were painted by two young men from New York who became known primarily to contemporary collectors for their graphic work in poster designs for World War I. Italian immigrant Vincent Aderente's mural in the west cove, called *The Dream of Brigham Young*, pictures a young, unbearded Brigham Young with Mormon Temple plans in hand. Young is standing in front of the construction site of the Temple with a "vision" of the building (which was completed in 1893, 16 years after his death) behind him, and other workers, one of whom is assumed to be Temple architect Truman Angell, standing at his side.

---

1  Architect Rob Pett reviews a full-size plaster model of one of the four marble lions that will sit at the east and west entrances. The pegs protruding from the mass aid the sculptor in preserving accurate proportions.

2  Henry Carsten, who has installed murals all over the world, puts the finishing touches on murals in the Senate Chamber.

3  Prior to the final patina process which adds color to the metal surface, the assembled and chased 11-feet tall bronze sculpture of *Arts and Education* dominate the interior of Artworks Foundry.

4  The loosely rendered seagulls in the rotunda dome will never be seen in such detail from the floor 165 feet below.

On the east cove is A. E. Forringer's *Discovery of the Great Salt Lake*. Forringer painted Brigham Young in a discussion with trapper Jim Bridger. The third figure, tasting the brine of the Great Salt Lake, demonstrates Bridger's claim that the water had so tainted the valley's soil that nothing would grow. Brigham lays out designs and prophecies about the valley and its future productivity.

In 2006, two new murals were commissioned for the north and south walls of the Chamber. David Koch, a Logan, Utah painter, won the newest Capitol commission with his interpretations of two events which helped to shape the character of Utah in the 20th century: on the north, the vote of the 1869 Salt Lake City municipal election (where Seraph Young became the first woman to vote in the United States) and on the south the Engen brothers building the first ski jump at Ecker Hill near Park City, a signal that the lucrative mining industry in the mountains of Utah was to be replaced by the outdoor recreation resorts as the primary economic engines of the state.

## Senate Chamber Murals

The Senate Chamber features three murals, one commissioned as part of the original building decoration and two recently completed. The Philip Dern proposal specified only a "typical Utah scene" on the north wall, behind the Senate President's dais. The resulting painting, by A.B. Wright and Lee Greene Richards, is a polyptych, or multiple-paneled landscape, showing Utah Lake, the state's largest freshwater lake. Artists Wright and Richards grew up in Salt Lake City only blocks from each other and famed Utah artist Mahonri Young. The three native sons went to Paris to study at the turn of the 20th century, each one establishing a national reputation in the visual arts.

The 2006 commission to complete the murals cycle in the Senate Chamber was awarded to Logan, Utah artist Keith Bond. His winning entries are landscapes of northern Utah, *Orchards along the Foothills of the Wasatch Mountains* and the stunning red rocks and ancient ruins of the southern Utah deserts, *Ancestral Home*.

## The Niche Sculptures

Without a doubt the most significant additions to the rotunda space in the restored Capitol are the 11-feet-tall bronze sculpture groups created by artists Eugene Daub, Robert Firmin, and Jonah Hendrickson. The original Capitol Commission report of

1915-1916 included recommendations from notable artists of the era to the effect that when budgets allowed for additional art in and on the building, themes were to be classical allegorical representations of all that was fine and noble about the state's past and present together with aspirations for the future.

Following the Commission's directive, the Arts Placement Subcommittee to the Capitol Preservation Board issued a call for qualified artists in 2006 to present proposals for the niche sculptures. The subcommittee determined four titles to be personified by the figures: *Arts and Education, Immigration and Settlement, Land and Community*, and *Science and Technology*.

Based on these themes, the competition-winning artists included an adult figure in each niche who gently mentors a youthful companion. Symbols grace each sculpture group to inspire future generations.

## Fourth Floor Galleries

The first exhibition of the Utah Art Institute opened in December of 1899. The Institute was the creation of the Legislature in January of that year at the direction of Alice Merrill Horne, the grand dame of Utah arts and the first woman elected to the Utah House of Representatives. The state's considerable art holdings, known as the Alice Collection in Horne's honor, began with a purchase from the annual exhibition with funds set aside in the "Art Bill." Within a decade, Capitol architect Kletting designed the Fourth Floor as the home for the offices and galleries of the Art Institute. Converted into much needed office space in the late 1960s, the Fourth Floor galleries have now returned to the restored building and will feature changing exhibitions on Utah's history, culture and arts.

With the restoration and installation of pre- and post-project artwork in the Capitol, the public art program envisioned by the original Capitol Commission is fulfilled. More than $1.2 million have been spent to complete this vision—the greatest amount spent on the arts for a project by the state in Utah's history. Funding has provided for several new purchases as well as commissions. A collection management system will ensure the care and custody of the Capitol Art Collection now and into the future.

1   Girard Hale, who briefly lived in Salt Lake City, painted the east and west lunettes in his Paris studio. The murals were shipped to the Capitol and installed in 1917. The detail of the male pioneer, provided by WCCFA, illustrates the specific conservation treatment employed by skilled conservators.

2   The Fourth Floor Gallery, which will host temporary and permanent exhibits, is suggested in a rendering by Paul Brown.

In addition to the murals and sculptures, the Capitol public arts program provides exhibits coordinated with education materials developed for the school children of the State. Visitors will learn about Utah, its land and its people, not only through the permanent art in the building, but also from the exhibits on the First and Fourth Floors.

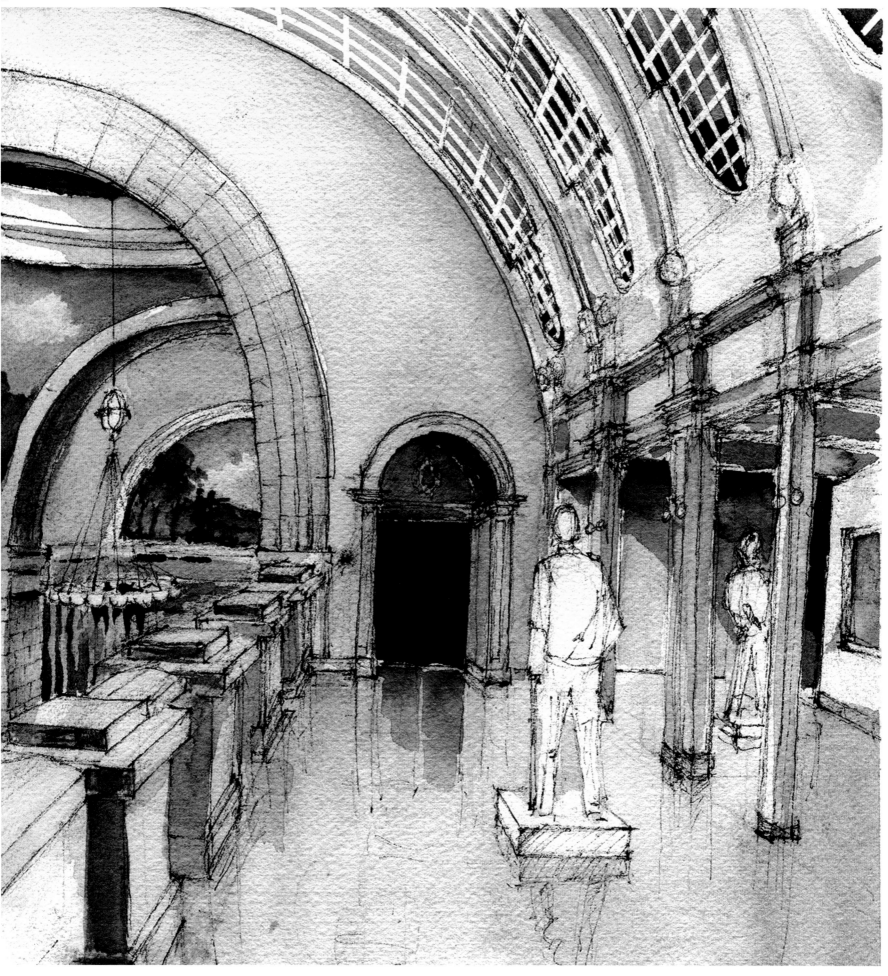

**LEFT** An estimated six million tons of rebar went into the base isolation and structural improvements for the Capitol.

# With Anxious Care

## Completion and Stewardship

One by one, the trailers, cranes and trucks of Capitol Hill's temporary construction town disappeared in late 2007. In their place, landscape specialists planted nearly 500 cherry trees along an oval pathway designed by John Olmsted in 1911. Lawns and decorative flower beds, inspired by the original planners and designers, reintroduced new concepts of landscape design. Memorials, both new and original, have been carefully spaced along the path in order for the visitor to experience an exceptionally beautiful park in an urban setting.

On the inside of the Capitol, scaffolding was dismantled and the plywood protecting century-old marble removed. Painters' buckets, carpenters' table saws and electricians' wire spools have likewise been taken away to reveal remarkable decorative painting and carefully crafted light fixtures. Elected officials moved into beautifully detailed offices with furniture designed to preserve the legacy of the past while incorporating the technology of the future. Staffers and volunteers resumed their

endless running between chambers as preparations for the legislative session began. Final reports were made. And closure to the reconstruction came at last.

Architects, engineers, craftsmen, and laborers have gone on to other job sites. Some retired. Those who worked on the project, however, will likely calculate several years of their lives by reference to their association with the restoration and base isolation of the Utah State Capitol in before-and-after phrases. In retrospect, the experience will likely be a pivotal point in several careers. In the future men and women may well see their experience here as a turning point and refer to it as such. "Before I was at the Capitol" will become a common prepositional phrase in more than a few sentences. Or, Capitol preservation veterans will be aware that "after I left the Capitol" will end up as a predicate to significant conversation about worthwhile experiences.

A possible reason for such a reaction in connection with the Utah State Capitol preservation project is that the building will have come to stand for a great deal more than simple employment. For many, it will be the singular most important experience in their long or short careers. For others it will be a realization that the

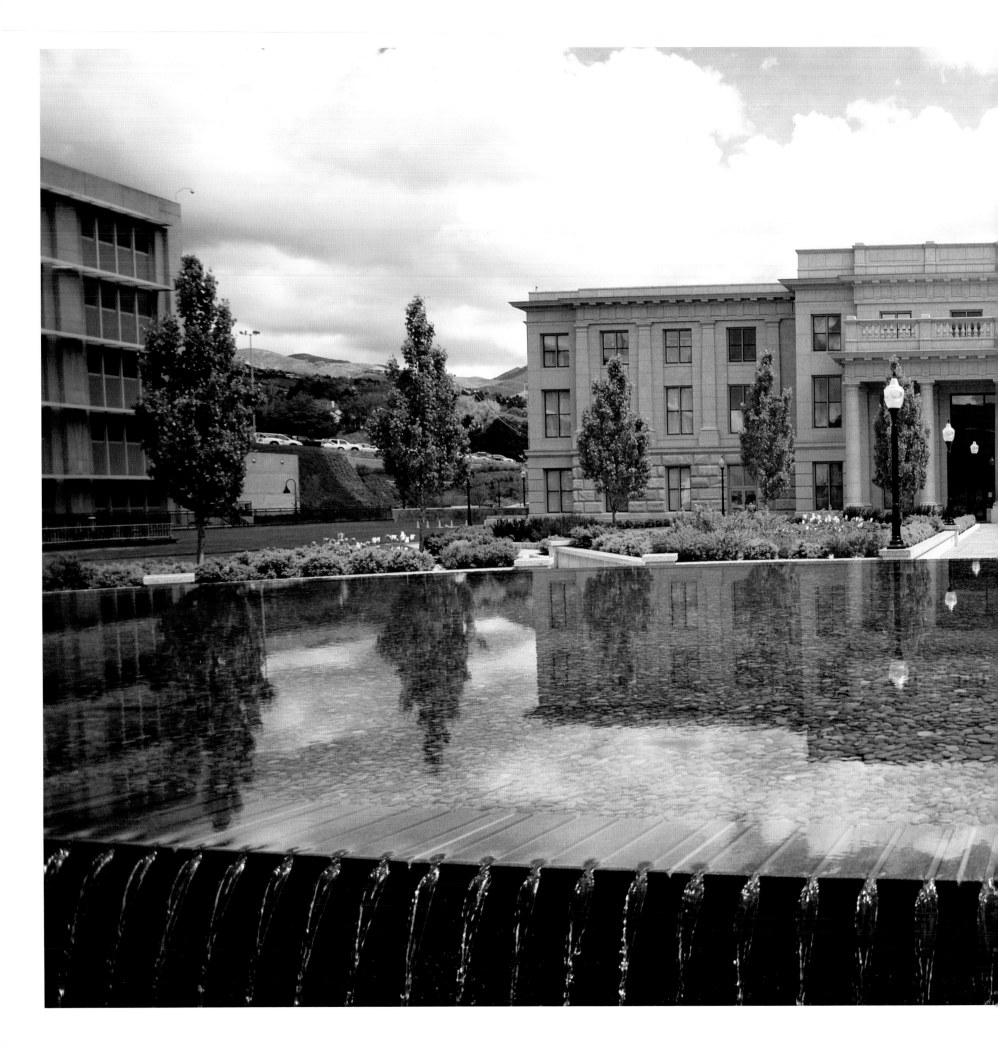

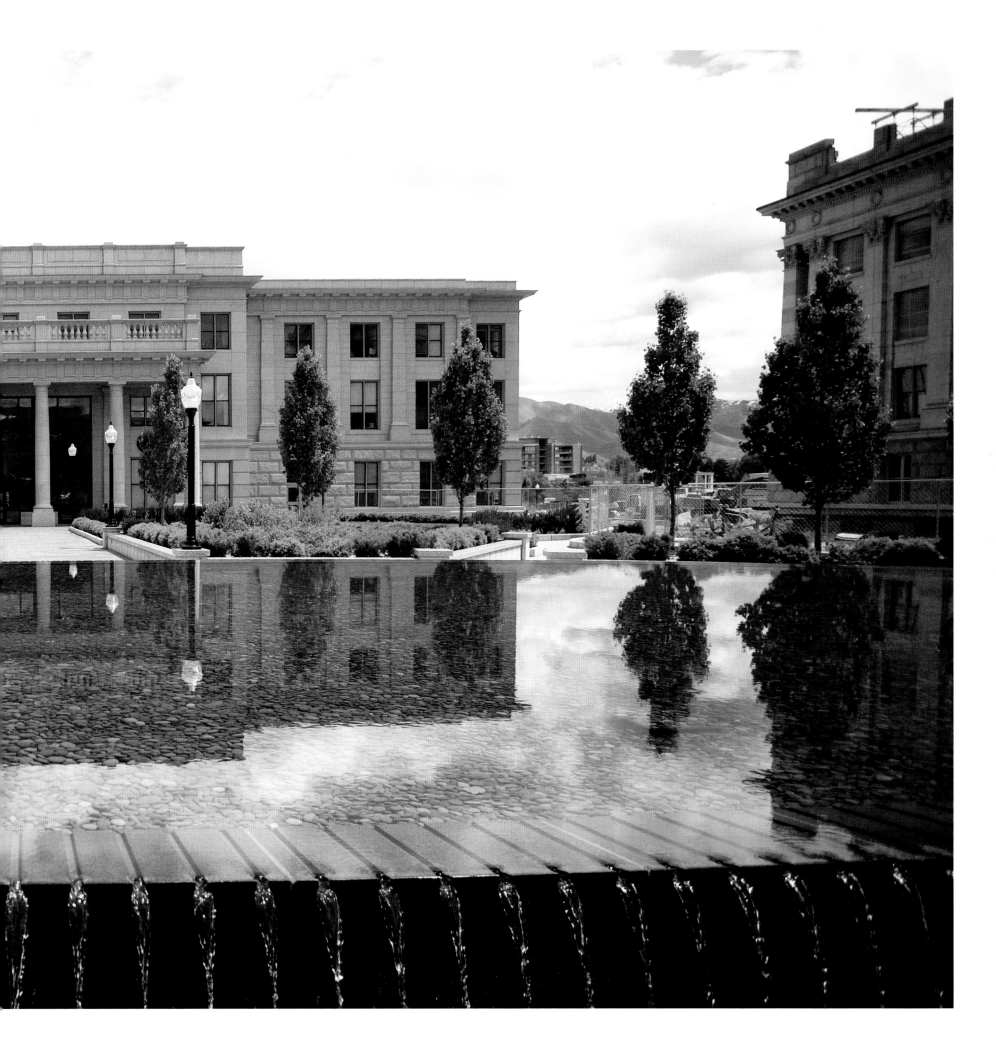

Capitol is a symbol of democracy. But for all involved, the time and toil, the sweat and labor invested at so many levels of devotion to the effort, have conveyed a sense of stewardship for the hill and its structures.

## The Enduring Symbol of Capitol Hill

The transformation of Arsenal Hill to Capitol Hill signified an important change in the life of the State. What was once a barren hill rocked by explosions in 1867 would become the seat of primary civic authority. Renaming Arsenal Hill was more than a little appropriate. Capitol is a derivative of the Latin word *caput*, meaning the head or top, or leader. In ancient Rome the patron deity of the city was Jupiter, chief of the gods and undisputed commander of the universe. Jupiter's more familiar Greek name is Zeus, the thrower of thunder bolts. His temple was built on the tallest of the fabled seven hills of Rome. The Hill was appropriately named Capitoline for three reasons: It was the seat, or residence, of Jupiter, the chief among the gods in the Roman pantheon; legend dictates that as the foundations of the great temple were being dug, workers recovered a human skull (or *caput*); and finally, it became by virtue of its importance as a temple precinct, the historic and religious center of the city. The temple of Jupiter Capitolinus, on its southern summit, was dedicated in 509 BC.

By the time Michelangelo arrived at Capitoline Hill in 1558 (later known as the Campidoglio), he was an old man. Pope Paul III wanted renovation. Over the centuries, the hill had become a rather tawdry, rundown place. After Michelangelo's renovation it was changed forever into the dynamic new center of Renaissance Rome, the headquarters for secular government and political life. Hence forward, Capitol, or the head, the site of Jupiter's earthly residence, became the universal symbol of governance and authority for our modern-day seat of government.

Symbols abound on Campidoglio Hill. Michelangelo brought the ancient Roman bronze figure of Marcus Aurelius on horseback to the center. The meaning of the equestrian statue was unmistakable in the Renaissance. A leader among men was seated on barely controlled energy, yet the steed was clearly under man's discipline.

Michelangelo built a new structure to flank the two existing buildings on the site, thereby closing off the view outward and creating a piazza. One building, the office and deliberative chamber for the Renaissance Senate, dominated the others, yet the other two buildings were visually the same weight and size. All three buildings were unified by the extraordinary oval piazza.

Michelangelo died before completion of his Capitol complex. His plan survives through a 1569 engraving by Étienne Dupérac. Utah's classical complex gracefully echoes Michelangelo's design in many ways. The Italian Capitol, with its deliberative chambers, dominates the piazza. Giant pilasters unify the façade and provide power and elegance to the structure. The plaza with its center pool is now surrounded by new supportive yet subservient Doric buildings. Michelangelo moved the tower, once at the side of the Senate building, to the center, thus creating an axial symmetry. The complex became a symbol of reason and power. Similarly, Utah's Capitol with its rotunda and cupola echoes the same axial symmetry of Michelangelo's design.

Finally, in Michelangelo's plan the ground at the center of the plaza rises slightly in a metaphoric allusion to the idea of the Capitoline Hill as the *Umbilicus mundi*, or center of the world. New York University's distinguished professor of fine art and architectural history, Marvin Trachtenberg, says the integrated, rationally organized, and animated entity of Michelangelo's Campidoglio was fundamental to the history of city planning.

Kletting's Utah Capitol was not the older, Richardsonian Romanesque style so popular with public buildings before the turn of the 20th century. Utah's choice of a hilltop with vistas, views, and planned structures is quintessentially Roman classical revival. His would reflect a change of considerable significance in Utah's architectural style and become a symbolic image of the state's new political power and prowess nationally. Through this building Utah was putting the nation on notice that it was no longer a small western religious stronghold, but rather, a legitimate and viable state in the Union.

---

**1**  Rome's Campidoglio, designed by Michelangelo in 1537, became the worldwide model for urban planning and design.

**2**  Michelangelo's brilliantly conceived oval plaza with the equestrian statue of Roman Emperor Marcus Aurelius at its center became the conceptual model for the Utah State Capitol plaza.

**3**  A 17th century engraving shows the effect of Michelangelo's relocation of the bell tower (or *campanile*) which achieved a serene balance of architectural forms on the plaza.

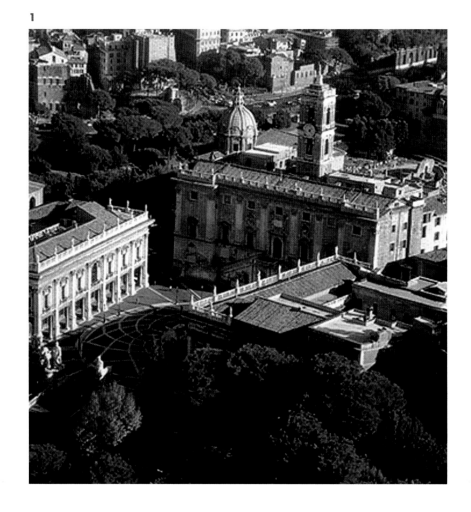

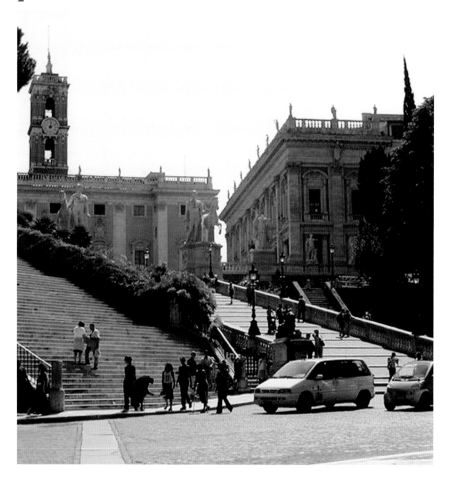

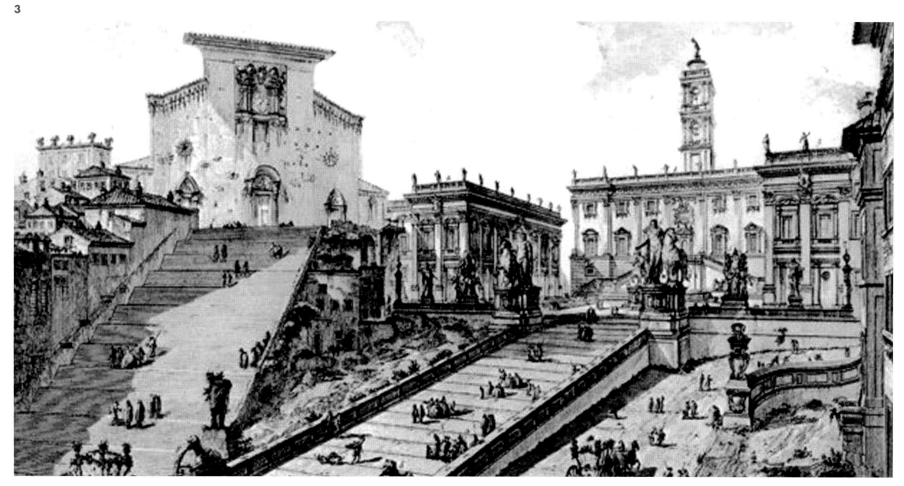

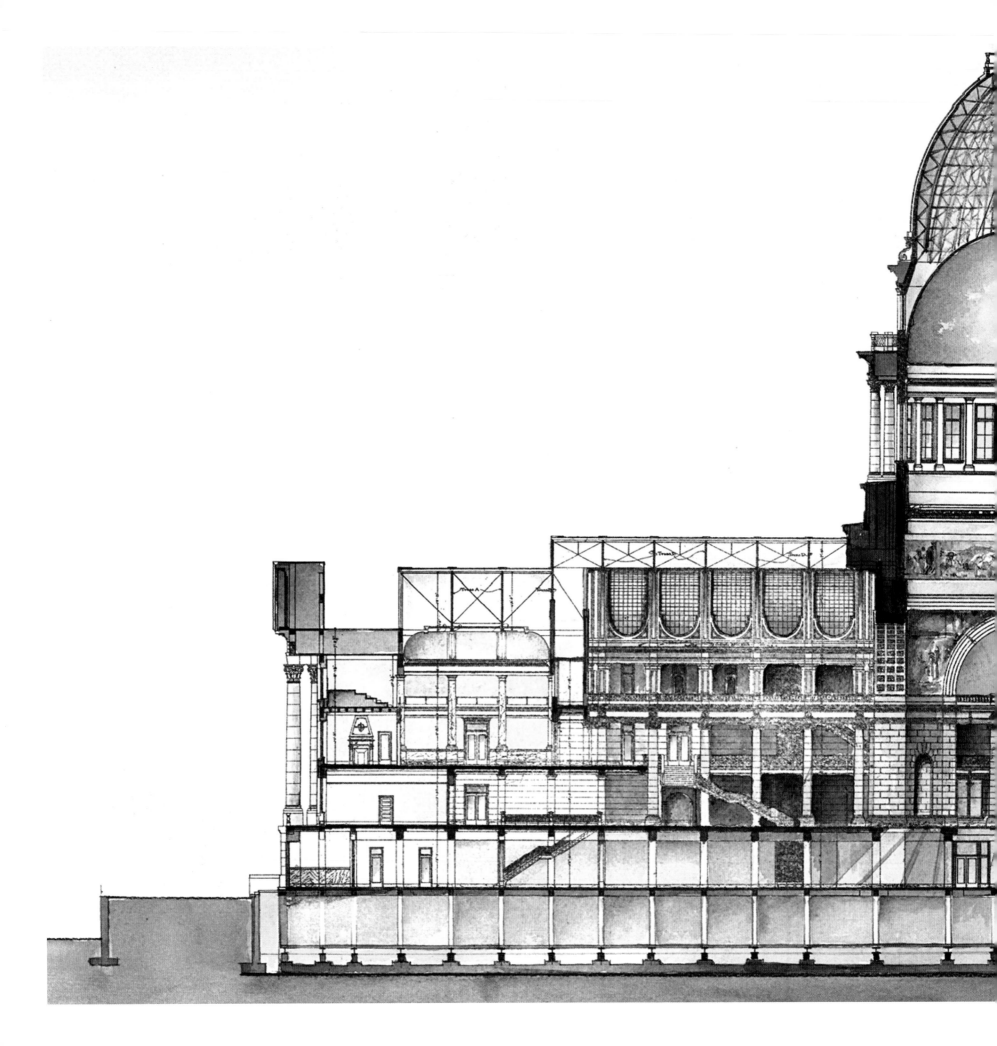

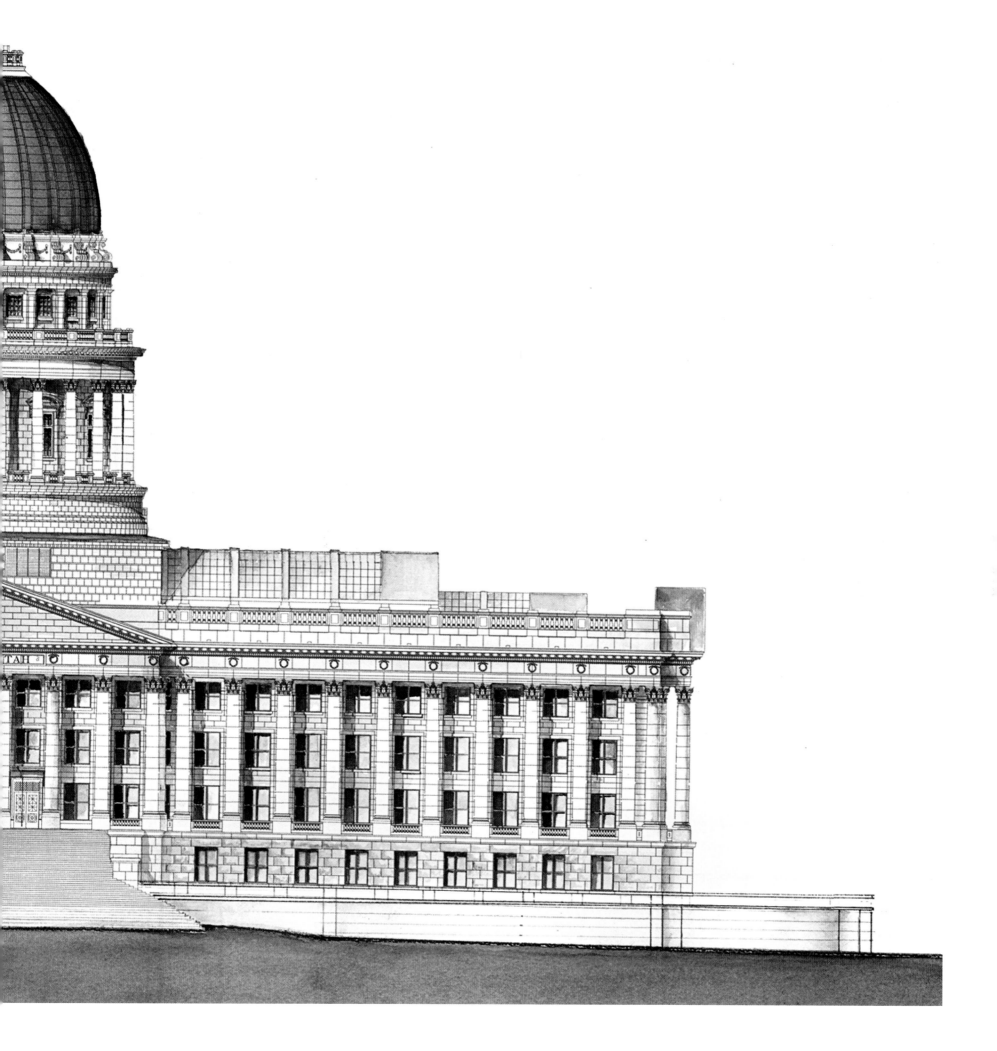

**1**

**2**

**3**

**4**

A stroll through the Capitol will reveal other symbols of government and authority: the acanthus garlands (or symbols of victory) and the bound shafts of wheat (symbols of unity) in the House; the giant, colossal Corinthian columns—the order preferred by the ancient Roman state as well as the Renaissance Rome of Pope Pius III; the rusticated stone on the ground floor of the building where the orderly "business" of the building was transacted; the grand staircase ascending to the chambers of the Senate, House of Representatives, and Supreme Court. All the chambers open to the illumination of the atrium. These symbols communicate unflinching strength.

But it is the building itself with its classical architectural space shaped by vaults, arches and walls for the purpose of ordered activities that gives meaning to this Capitol as the head and seat of government. Yet the building as a symbol is more than the architecture, the decorative painting and the beautiful ornamented fixtures. It is the physical manifestation of the hard-won rights and liberties provided by the Constitution of the United States. The building represents an open government by the people and for the people. The building is also a symbol of freedom of speech as well as the right of assembly. This is the gift of the Capitol to not only the state of Utah, but to a nation and the world. The Utah State Capitol's soaring skylights and vaulted rotunda walls combine to provide, arguably, the most open of all state capitols in America. The location of its chambers, and the office of the Governor are all clearly visible from the rotunda—yet another symbolic reference to the open government provided in our constitution.

## More Than a Place to Work

When the trailers disappeared they left orderly grounds, an extraordinary complex of buildings and plazas. During construction, anxiety over decisions, costs and procedures was built into the daily schedule for architects, planners, engineers and State leaders. The fiscal investment for a small state was a foreboding challenge met with great resolve over seven years by multiple legislatures and governors. Each decision was carefully weighed and evaluated. In the end, the single most important consequence of the decision to restore and preserve the Capitol is the need for active stewardship—the continuing responsibility for the results achieved.

---

1   John Vigil, Labor Foreman for Jacobsen Construction.
2   Michelle Petersen, Carpenter for Jacobsen Construction.
3   Leobardo Gonzales, Mason for Child Enterprises.
4   Don Calvin, Equipment Operator for Mackay Contracting.
5   Roberta Lovato, Security Guard, for Diamond Detective Agency.

The title of this commemorative book comes from English critic and preservationist John Ruskin, a particular favorite of Utah's historic preservation officer and anglofile Wilson Martin. In Ruskin's seminal work on historic preservation he gave the people of the State their cue.

With the compliments of the Utah State Capitol Preservation Board and the government it represents, this commemorative volume not only celebrates the restoration of the Capitol but also the consequences of its restoration. The Board, through Ruskin's voice, lays down the challenge created by its actions to future tenants and generations:

Watch an old building with anxious care; guard it as best you may, and at any cost, from every influence of dilapidation. Count its stones as you would jewels in a crown; set watches about it as if at the gates of a besieged city; bind it together with iron where it loosens; stay it with timber where it declines;...and do this tenderly, and reverently, and continually, and many a generation will still be born and pass away beneath its shadow.

5

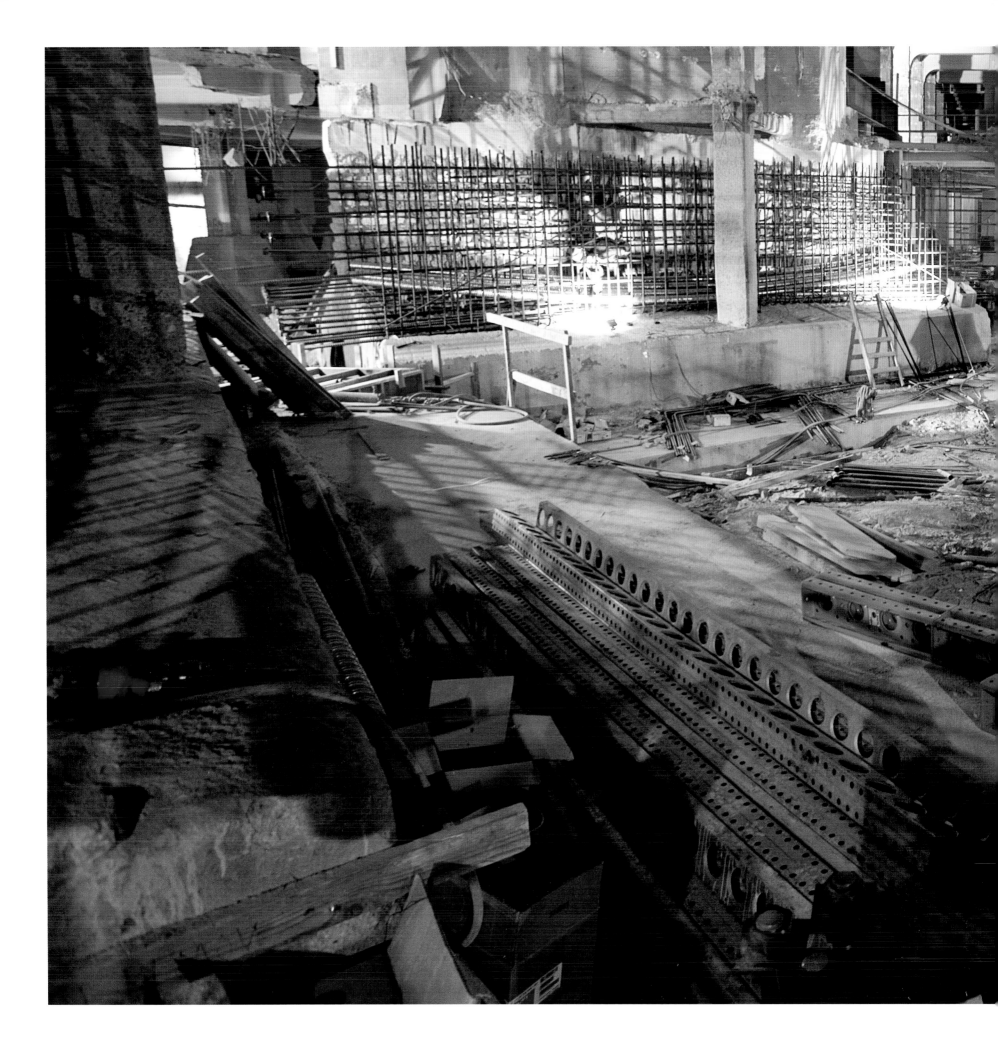

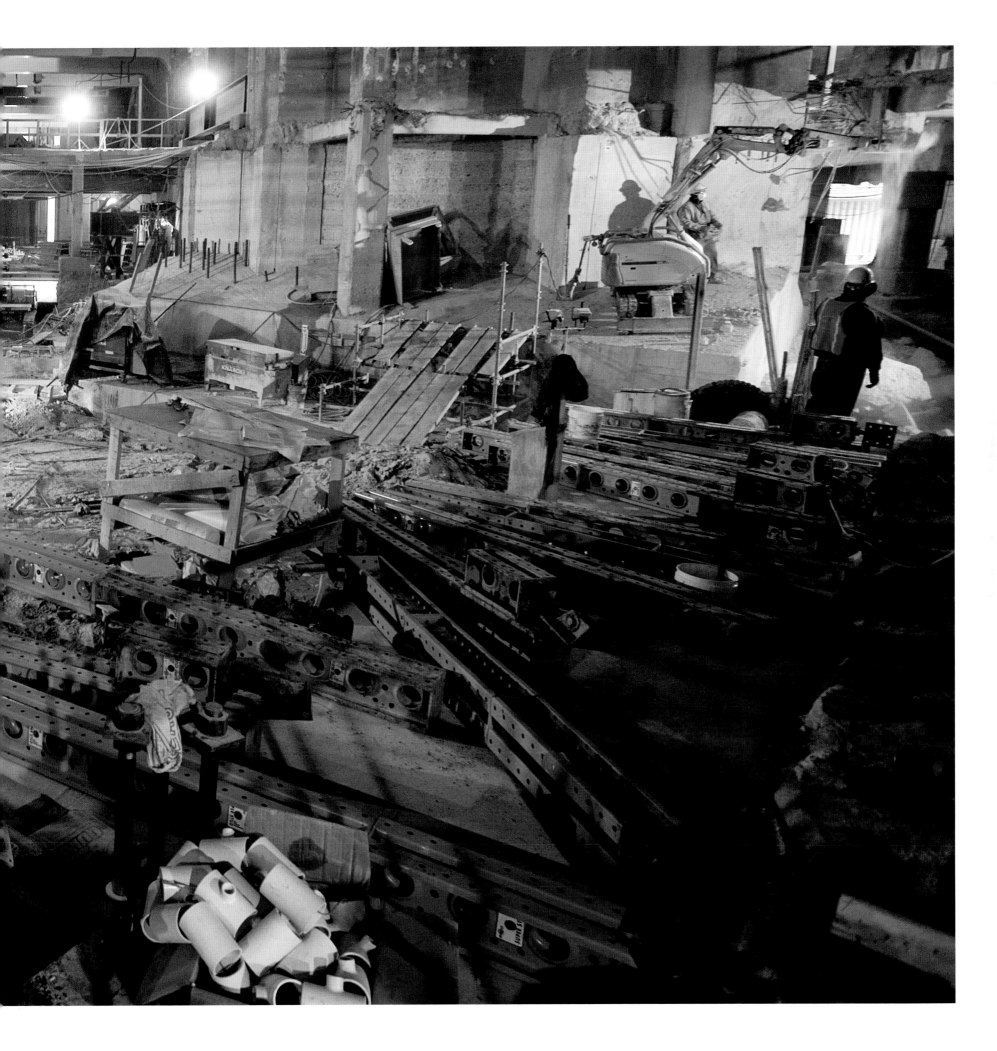

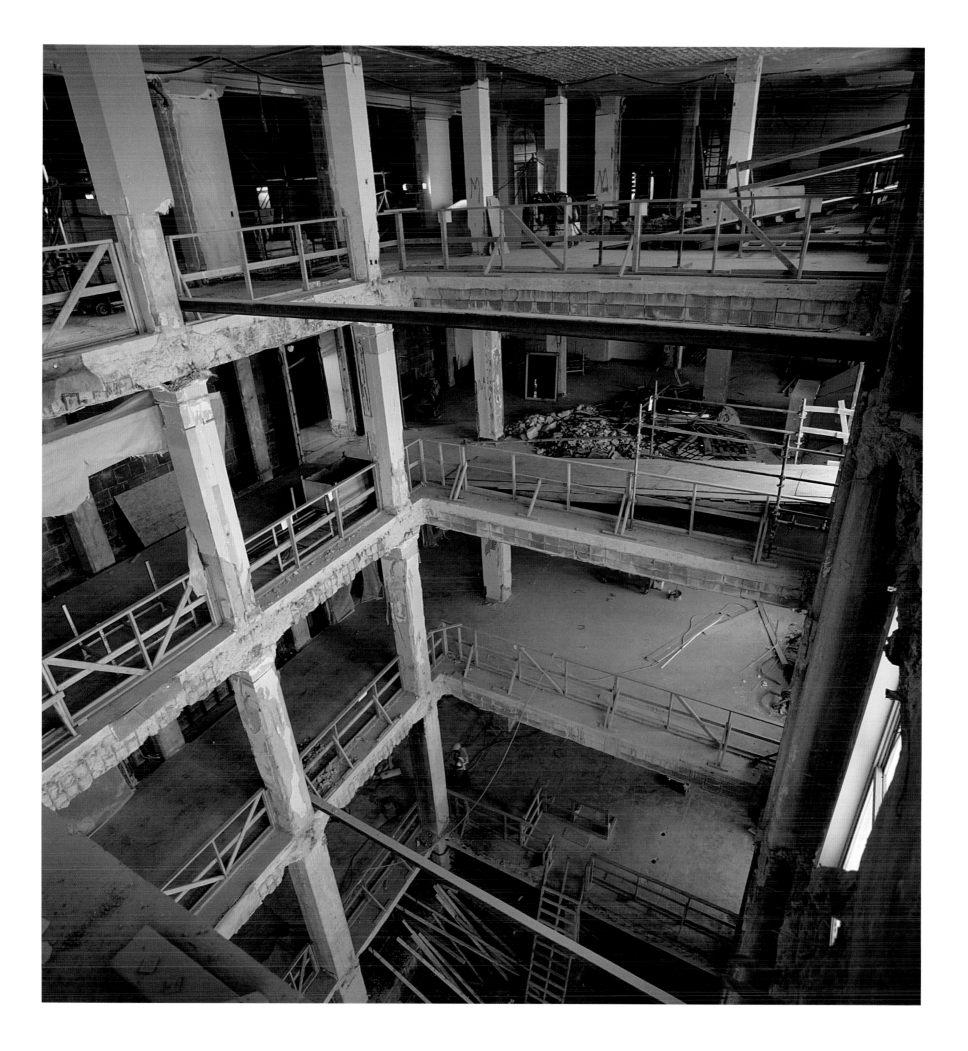

# Glossary

Abacus (Ab a kis, a BACK is)

A slab on the top of a capital, crowning the column and supporting the entablature.

Acanthus (a KAN this)

Small shrubs native to the Mediterranean, prized among the Greeks and Romans for the elegance of their leaves. Acanthus have leaves with spiny margins arranged on each side of a common stalk. The leaves are used to decorate capitals of the Corinthian and Composite Orders. Acanthus is also found as a decorative feature elsewhere in Classical Architecture.

Acroteria

Pedestals or plinths at the apex and lower extremities of pediments. They can support statuary or ornaments, or can be unadorned.

Arch

A construction of blocks of material arranged in a curve supporting one another by mutual pressure: an arch so formed over an opening is capable of carrying a superimposed weight. Each block in an arch is called a voussoir and the block in the center is called the keystone.

Architrave (AR ka trave)

The lowest of the three main parts of an entablature. The undecorated lintel resting on the columns.

Attic

A story built above a wall cornice.

Baluster

One of the upright, usually rounded or vase-shaped supports of the balustrade.

Balustrade

A parapet composed of balusters with a rail, usually found with pedestals or some stronger element at the ends of runs of balusters.

Band

A face or fascia. A flat, low, square profiled molding encircling a building or running across its façade. The strip from which dentils project.

Base

That part of a column between the shaft and the pavement or pedestal.

Capital

The head or crowning feature of a column or pilaster.

Column

A supporting pillar consisting of a base, a cylindrical shaft and a capital.

Colonnade

A row of columns, supporting an entablature and usually one side of a roof. When a colonnade stands before a building it is called a portico, and if it surrounds a building is called a peristyle.

**Colossal Order**

An order where the columns or pilasters rise from the ground more than one storey, also known as Giant Order.

**Composite Order**

A Roman Order, mixing features of Ionic and Corinthian orders.

**Corbelled Arch**

In architecture, a "false arch" bridging a gap by means of overlapping blocks of masonry.

**Corinthian Order**

The most ornate of the five Classical Orders, characterized by a slender fluted column having an ornate, bell-shaped capital decorated with acanthus leaves.

**Cornice** (KOR nis)

A decorative moulded projection at the top of a wall, window or construction. The upper part of an entablature.

**Dentil** (Root "dent" means tooth)

A small rectangular block used in a series forming a moulding under an Ionic, Corinthian or Composite cornice.

**Doric Order**

The Classical Order characterized by sturdy proportions, a simple cushion capital, and a frieze of triglyphs and metopes.

**Drop**

Small drop-like projections carved below a triglyph or below a Doric entablature. Also called a "gutta."

**Drum**

A circular structure supporting a dome.

**Eaves**

The lower edge of a pitched roof which overhangs the face of a wall. An eaves cornice is a cornice in that position.

**Echinus** (i KY nis)

A convex moulding just below the abacus of a Doric capital.

**Egg and dart**

A moulding consisting of egg-shaped figures alternating with arrowheads.

**Engaged column**

A column attached to, or partly sunk into, a wall. Also called an "applied column" or "attached column".

**Entablature**

The upper part of an Order, consisting of an architrave, frieze, and cornice.

**Entasis** (en TAY sis)

The very slight convex curve used on Greek and later columns to correct the optical illusion of concavity which would result if the sides were straight. Also used on spires and other structures for the same reason.

**Fluting** (FLOO ting)

A decorative motif consisting of a series of uniform, usually vertical, flutes (grooves).

**Fret**

A decorative design contained within a band or border, consisting of repeated, often geometric fixtures. Also called "key pattern".

**Frieze** (freez)

The horizontal part of an entablature between the cornice and the architrave. It may be plain or decorated.

Gable

The end wall of a building, the top of which conforms to the slope of the roof which abuts against it.

Greek Orders

The Doric, Ionic, and Corinthian orders of architecture, each of which is distinct from Roman versions.

Gutta (GUT a) **Plural:** guttae (GUT ee)

Small drop-like projections carved below a triglyph or below a Doric entablature. Also called a "drop."

Intaglio

Sculpture where the design is hollowed out or incised. Intalgio also means the carved work of an Order, or carving on any part of an edifice.

Intercolumniation

The clear space between two adjacent columns, usually measured at the lower parts of the shafts.

Ionic Order

The Classical Order characterized by its capital with volutes, and by elegant detailing; less heavy than the Doric, less elaborate than the Corinthian.

Jamb

The side of a window or door opening bearing the weight of the wall.

Lantern

A turret, drum, or other structure raised above a roof or dome with windows around the ides to light the apartment below.

Lintel

A beam over an opening which supports the wall above.

Lunette

A semi-circular opening or blind recess.

Metope (MET a pee)

Any of the spaces between two triglyphs on a Doric frieze.

Modillion (mo DILL yin)

An ornamental bracket, usually in the form of a scroll with acanthus, used in a series beneath a Corinthian, Composite or Roman Ionic cornice.

Mural

A painting on a wall, or a monument which is fixed to a wall.

Niche

A recess in a wall for a statue, vase, or other ornament. Niches are often semi-circular, and are arched.

Order

In Classical Architecture, an assembly of parts consisting of a column, base, capitals, and entablature, proportioned and embellished in consistency with one of the Five Orders. These are Tuscan, Doric, Ionic, Corinthian and Composite.

Pediment (PED a ment)

In Classical architecture, a low-pitched gable above a portico, formed by running the top member of the entablature along the sides of a gable. Also a similar feature above doors, windows, etc. It may be straight-sided or curved. Pediments are found over niches, windows, doors and other features.

Pendentive

A concave, triangular piece of masonry, four of which provide the transition from a square area to the circular base of a covering dome. Although they appear to be hanging (pendant) from the dome, pendentive in fact support it.

Peristyle

A series of columns surrounding a building or enclosing a court.

Pilaster (pi LAS ter)

A shallow rectangular column projecting only slightly from a wall and, in Classical architecture, conforming to one of the Orders.

Plinth

A square or rectangular base for column, pilaster or door framing.

Portico

A structure forming a porch in front of a building, and consisting of a roofed space open or partially enclosed at the sides, with columns, forming the entrance. A portico often has a pediment.

Rosette (row ZET)

A rose-shaped patera used to decorate strings, architraves, etc. A patera is a circular ornament, resembling a dish, often worked in relief on friezes.

Rotunda

A circular building or room, usually with a dome or a domed ceiling over it.

Skylight

A window in a ceiling or roof.

Triglyph (TRY glif)

An ornament in a Doric frieze, consisting of a projecting block having on its face two parallel vertical glyphs or grooves and two half grooves or chamfers on either vertical end, that separate the metopes.

Tuscan Order

The simplest of the Orders of Classical Architecture. The shaft of the column is never fluted, and the capital has a square abacus.

Tympanum (TIM pa nim)

The ornamental recessed space or panel enclosed by the moulding of a pediment. Also the space between an arch and the lintel of a door or window.

Volute (va LOOT)

A spiral scroll on an Ionic capital. Smaller versions appear on Ionic, Composite and Corinthian capitals.

---

From Curl, James Stevens. *Classical Architecture*
*An Introduction to its Vocabulary and Essentials, with a Select Glossary of Terms*
New York: W.W. Norton & Company, 2003.

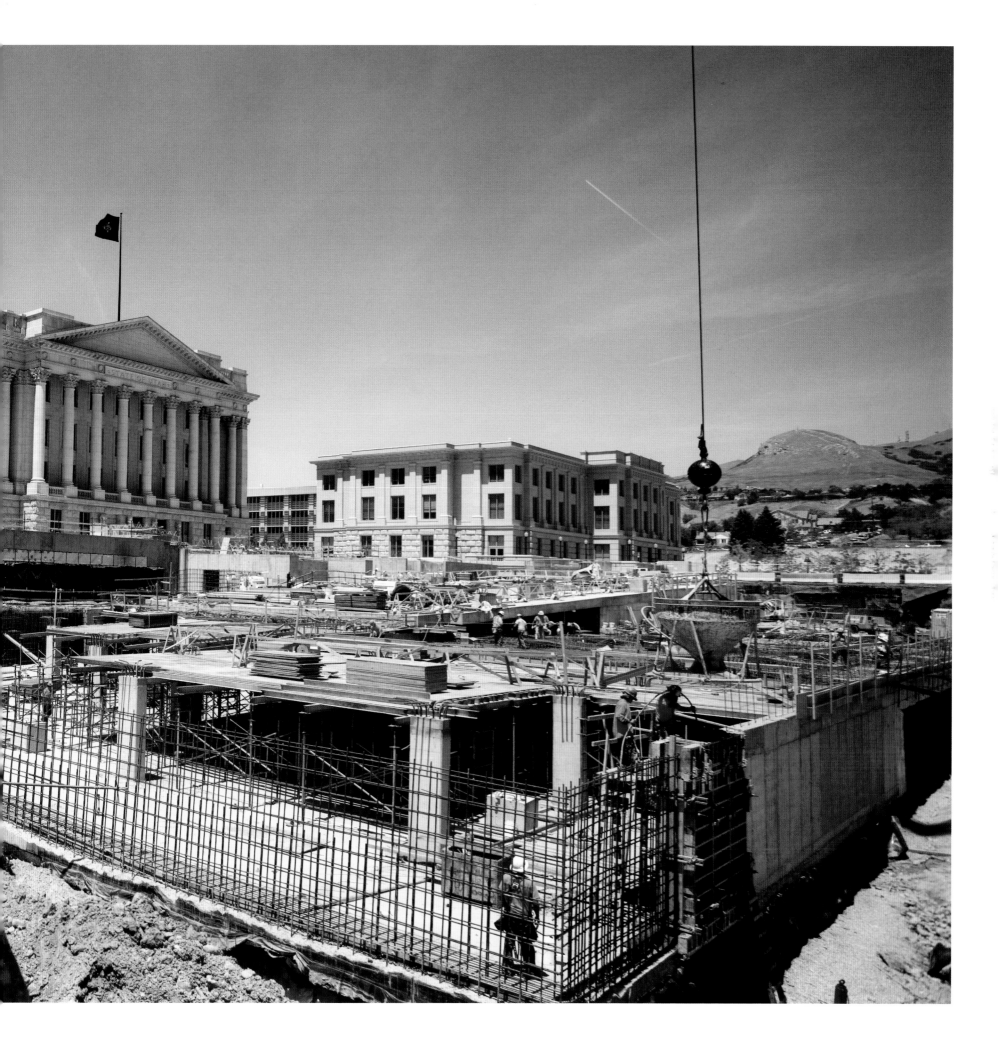

# Contributors, Notes and Sources

Following the comments on contributors to this commemorative book, a list of sources and suggested readings on the Capitol preservation project has been provided. The purpose of the book on the restoration of the Capitol suggested a system of citations in the form of references within the text. In the case of whatever quotations come from the collected correspondance and reports of the Capitol Commission or other documents, every effort has been made to include the salient retrieval information within the text. Interested individuals wishing more in-depth information may access those citations, along with video clips and additional digital photos through the Utah State Capitol Preservation Board's information system called the eMuseum or by contacting the Capitol Preservation Board directly.

## Contributors

In the preparation of this commemorative book a team of readers, editors, writers, and general facilitators have become an impressive collaborative team. The list is much broader than individuals who have been recognized. With apologies for inadvertent omissions, below is a brief annotated list of contributors.

The members of the Utah State Capitol Preservation Board are unalterably committed to preservation of the building as a treasure. Their generous support was a constant during the process. The Capitol Arts Placement Subcommittee offered expertise, patience and insight. The chair and vice-chair of the subcommittee, Karen Hale and Peggy Wallace, are true public servants as well as inspiring and bright human beings. Karen, acting as part of the editing team, read every word of the text and with uncanny insight corrected and steered it in the direction it needed to go. Every author should have such an advocate. Michael Dunn has made the project virtually a member of his family for the last several years. His creative abilities are readily apparent on the pages of the book—intellect and kindness may not be, but

they are acknowledged here. Special thanks as well to Roger Jones, who provided such brilliant art direction for the book.

David Hart has contributed entire sections on the building and the architecture. His commitment to the enterprise was extraordinary. He is the lead car in the caravan.

Architect and historian Charles Shepherd compiled and edited the correspondence of the original Capitol Commission as well as other documents associated with the building. His abundant patience in sharing what he knows could not have been more welcome. The other architects in the CRG office, including Robert Pett, Karen Ferguson, Breanna Brown and Derrick Larm prepared every request for drawings, letters, and information so that it was not only useful but clear and concise for readers at any level of competency in architecture.

Other members of the construction team charpentier who went out of their way to help include Dave Marshall, Mark Chavez, Scott Carpentier, Brooks McIntyre and Suzanne Lovato. Jerod Johnson of Reaveley Associates, the engineering part of the team, can explain even the most arcane information about base isolation to make it sound like the most simple yet most important concept on the planet. In fact, every single individual in the "trailers" made life easier during the preparation of the text.

Utah State Historical Society and Archives enthusiastically found and digitized documents and counseled the team on what to look for and why, particularly Wilson Martin, Phil Notarianni, Patricia Smith-Mansfield and Kenneth Williams.

Joseph Ligori and the staff of facilities management for the Capitol have been delightful and informed mentors who came to help at the drop of a hat. Joe has an unrivaled cumulative knowledge of the building which he has readily shared.

Without the Utah Arts Council, and specifically Lila Abersold, this book would not have gone forward. The Council graciously made its records on the Alice Art Collection and Alice Merrill Horne available and usable.

Ron Fox can be counted on to find anything; his helpful goodness was invariably useful.

Richard Tholen, a project architect from the Division of Facilities and Construction Management (DFCM), and his wife Faye have written and researched articles included in the book. And, because of space limitations, their work is also published online in the documents about the history of the Capitol. Richard's charming memoir on his experiences with the Capitol over 30 years has been invaluable. Faye's writing and research skills were heaven sent. The Tholens brought one-of-a-kind photos to the office as part of their considerable contributions.

James McConkie has listened to more drafts and "trial runs" of subject matter than he should ever have to. He is a true and abiding friend.

In addition to David Hart, current and former Capitol Preservation Board professionals have collaborated on the project, each with particular skills. They include Sarah Whitney, Michelle Poland, Lisa Morrise, Pam Lanningham, Michael Hussey, Paul Ernst, James Egan, and former staffer Tasha Williams as well as Elisha Buhler Condie—an incomparably capable assistant. Finally, Allyson Gamble has labored under physical crises of enormous proportions. Despite a complete heart transplant she continues to dedicate her time and utterly superb talents and intellect to the project and to the success of the team.

---

**1** Former State Senator Karen Hale (left), who spent numerous hours editing *With Anxious Care*, reviews final galley proofs with author Judith McConkie.

**1**

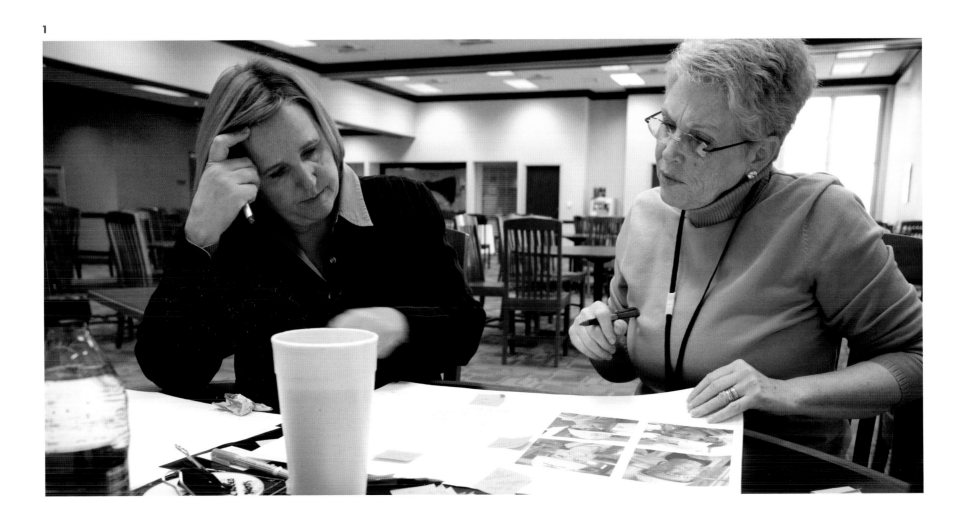

## Suggested Readings

Alexander, T (2003). *Utah, the Right Place: The Official Centennial History* (Rev. ed). Layton: UT: Gibbs Smith Publishing.

Applebaum, S. (1980). *The Chicago World's Fair of 1893: A Photographic Record.* New York: Dover Publications, Inc.

Arrington, L. (1985). *Brigham Young: American Moses.* New York: Alfred A. Knopf, Inc.

Arrington, L. (1993). *The Great Basin Kingdom: An Economic History of the Latter-day Saints, 1830-1900* (Paperback ed.). Salt Lake City, UT: University of Utah Press.

Bazin, G. (1967). *The Museum Age.* New York: Universe Books, Inc.

Benzon, P. R., Geyser, J. L., and Haymond, J. B. (Eds.) (1996). *The Utah State Legislature: Centennial History 1896-1996.* Salt Lake City, UT: Office of the Third House, Utah State House of Representatives.

Blashfield, E. (1913). *Mural Painting in America.* New York: Charles Scribner's.

Bolotin, N. and Laing, C. (2002). *The World's Columbian Exposition: The Chicago World's Fair of 1893.* Chicago: University of Chicago Press.

Bradley, M. S. (2005). *Pedestals and Podiums: Utah Women, Religious Authority and Equal Rights.* Salt Lake City, UT: Signature Books.

Bradley-Evans, M. S. (2005). *Women in the Arts: Evolving Roles and Diverse Expressions.* In P. L. Scott and L. Thatcher (Eds.), *Women in Utah History: Paradigm or Paradox* (Logan, UT: Utah State University Press, 324-259.)

Carter, D. R. (2003). *Founding Fort Utah: Provo's Native Inhabitants, Early Explorers and First Year Settlement* (paperback). Provo, UT: Provo City Corporation.

Clawson, S. (1915). *Some Reasons Why the Polished Monolithic Columns Were Not Used in the Utah State Capitol.* Unidentified Publication Source. BYU Special Collections #192538.

Cooper Roberts Architects (Eds.) (2000). *Building and Grounds Restoration Master Plan and Historic Structures Report.* Available: utahstatecapitol.utah.gov/restoration (Retrieved September 26, 2007.)

Dunningham, C. and Perry, G. (Eds.) (1999). *Academies, Museums and Canons of Art.* New Haven, CT: Yale University Press.

Einreinhofer, N. (1997). *The American Art Museum. Elitism and Democracy.* London: Leicester University Press.

Gilmore, R. (Ed.) (1982). *Over a Century: A History of the School of the Art Institute of Chicago, 1866–1981.* Chicago: The School of the Art Institute of Chicago.

Hart, D. H. and Brown, P. (2006). The Utah State Capitol 20 Year Master Plan for the Utah State Capitol. Available: utahstatecapitol.utah.gov/restoration (Retrieved September 26, 2007.)

Hart, D.H. (2007). The Story Beneath and Behind the Utah State Capitol. Available: utahstatecapitol.utah.gov/restoration (Retrieved September 26, 2007.)

Horne, A. M. (1914). *Devotees and Their Shrines: A Handbook of Utah Art.* Salt Lake City, UT: Deseret News.

Hyman, I. and Trachtenberg, M. (2002). *Architecture from Prehistory to Postmodernity, Second Edition.* New York: Harry N. Abrams, Inc.

Jordy, W. H. (1976). *American Buildings and Their Architects: [Part III] Progressive and Dynamic Ideals at the Turn of the Twentieth Century. Garden City, NJ*: Anchor Books. (Original work published 1972.)

Kenutcky Historical Society (2007). Kentucky State Capitol Artists. Available: history.ky.gov/index.php (Retrieved September 26, 2007.)

Larson, E. (2003). *The Devil in the White City: Murder, Magic and Madness at the Fair that Changed America.* New York: Crown Publishers.

Manson, Grant Carpenter, "Frank Lloyd Wright and the Fair of '93," *The Art Quarterly* (Detroit Institute of Art) XVI, 2, Summer 1953, 114-123.

Martin, W. (2007). The Principles of Historic Preservation and the Utah State Capitol. Available: Utahstatecapitol.utah.gov/restoration (Retrieved September 26, 2007.)

May, D. (1987). *A People's History of Utah.* Salt Lake City, UT: University of Utah Press.

Notarianni, Philip F. (1994). *Mining in Utah.* In A. K. Powell, (Ed.) (1994). *Utah History Encyclopedia.* Salt Lake City, UT: University of Utah Press.

Olmsted, F. L. Sr. (1881). *A Consideration of the Justifying Value of a Public Park.* Boston: Tolman and White Printers.

Olmsted, J. (1894-1912). Utah State Capitol Grounds of Public Buildings. Available: rediscov.com/olmsted/default.asp?IDCFile=/olmsted/genb.idc (Retrieved September 26, 2007.)

P. L. Scott and L. Thatcher (Eds.), *Women in Utah History: Paradigm or Paradox.* Logan, UT: Utah State University Press.

Powell, A. K. (Ed.) (1994). *Utah History Encyclopedia.* Salt Lake City, UT: University of Utah Press.

Rosenzweig, R. and Thelen, D. (1998). *Popular Uses of History in American Life.* New York: Columbia University Press

Ruskin, J. (1880). "A Museum or Picture Gallery." In *The Works of John Ruskin.* Edited by E. T. Cook and Alexander Wedderburn. London: George Allen, 1908, 34: 247-262.

Ruskin, J. (1989). *The Seven Lamps of Architecture (2nd ed.).* Toronto, Canada: General Publishing Company, Ltd. (Original work published 1889.)

Sanders, D. (2004). *It's My State! Utah.* New York: Benchmark Books.

Sawyer, P. L. (2007). *The Meaning of Architecture.* Available: victorianweb.org/authors/ruskin/sawyer (Retrieved September 26, 2007.)

Spry, W. et al (1911). *Program of Competition Utah State Capitol Building.* No publisher listed.

State of Utah (1917). *The Report of the Capitol Commission 1915-1916.* Salt Lake City, UT: Tribune-Reporter Printing Co.

Steffensen-Bruce, I. A. (1998). *Marble Palaces, Temples of Art: Art Museums, Architecture and American Culture, 1890-1930.* London: Associated University Presses.

Stefoff, R. (2001). *Celebrate the State: Utah.* New York: Benchmark Books.

Stegner, W. (1964). *The Gathering of Zion: the Story of the Mormon Trail.* New York: McGraw-Hill.

Stevenson, E. (1977). *Park Maker: A Life of Frederick Law Olmsted.* New York: Macmillan Press.

Swanson, V. G., Olpin, R.S., and Seifrit, W. C. (1991). *Utah Art.* Salt Lake City, UT: Gibbs Smith Publisher.

Swanson, V. G., Olpin, R.S., and Seifrit, W. C. (1997). *Utah Painting and Sculpture.* Salt Lake City, UT: Gibbs Smith Publisher.

Utah State House of Representatives (1899). *House Journal of the Third Session of the Legislature of the State of Utah.* Salt Lake City, UT: Tribune Job Printing Co.

Shepherd, C. (Ed.) (1911-1916). *The Collected Letters of the Utah State Capitol Commission.* Salt Lake City, UT: Capitol Preservation Board.

Warrum, N. (Ed.) (1919). *Utah Since Statehood, Illustrated.* Chicago: The S. J. Clarke Publishing Company.

Whitley, C. (Ed.) (2006). *From the Ground Up: A History of Mining in Utah.* Logan, UT: Utah State University Press.

Wilson, W. H. (1989). *The City Beautiful Movement.* Baltimore, MD: Johns Hopkins University Press.